P9-DDT-034

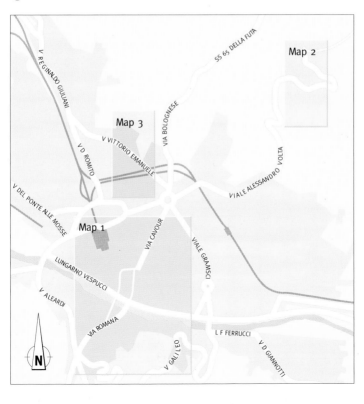

First United States Edition

ISBN 0-8212-2157-4
Library of Congress Catalog Card Number
94-78809

Bulfinch Press is an imprint and trademark
of Little, Brown and Company (Inc.)
Published simultaneously in Canada by
Little, Brown & Company (Canada) Limited

PRINTED IN SINGAPORE

ART IN *focus*

Florence

FLORENCE

Nicholas Ross

A Bulfinch Press Book
Little, Brown and Company
Boston • New York • Toronto • London

CONTENTS

The visitor embarking for the first time on a tour of Florence could easily feel overwhelmed by its artistic riches. This guide aims to help those who have only a limited amount of time to spend exploring the city by describing the best art galleries, paintings, sculptures, churches and other notable buildings. It is personal and selective, designed specifically to steer the tourist towards the city's artistic highlights rather than present a comprehensive list of everything that can be seen in Florence. The golden period of Florentine art coincided with the Renaissance. Indeed, Renaissance art was born in Florence and several of the most famous figures in the history of art were either natives of the city during the period or spent major parts of their careers there. Florence also has much to offer from earlier and later periods, but in concentrating on the high points this book devotes more attention to the fifteenth century than to any other.

The history of Florence can be traced back to Roman times: the colony first came to prominence in the time of Julius Caesar in 59 BC. Various scraps of information survive about the early centuries of the city's existence (for example it is known to have had a bishop in AD 313), but it seems to have been a place of only marginal importance for over a thousand years after its foundation. The first major personality in the city's history was Matilda of Tuscany (1046–1115). She was ruler of Tuscany (the region in which Florence lies) for forty years and played a prominent part in Italian history of the time by virtue of her alliance with the Pope against Henry IV, the Holy Roman Emperor. Matilda was a woman of strong Christian faith and she had decorations carried out at two religious buildings that are of great significance for the Florentines – the Baptistery (page 18), important because John the Baptist is patron saint of the city, and San Miniato (page 118), the site of the first Christian martyrdom. The coloured marble facades of these buildings greatly influenced Florentine design throughout the Renaissance.

Under Matilda new city walls were built in 1078 to protect a swelling population of 20,000. Trades grew and associations were formed into guilds as a general sense of prosperity replaced subsistence. Inevitably, the

1. OVERVIEW OF
FLORENCE

2. VIEW OF FLORENCE
SHOWING THE DUOMO

population increased as people moved in from the countryside. This in turn precipitated a crisis in the church, as it became clear that population growth was outstripping the limited influence of the church hierarchy. Two evangelical, urban-based orders rapidly evolved to meet this challenge, the Dominicans, founded in 1221, and the Franciscans of 1209.

Florence had traditionally been governed by a loose association of feudal Lords who applied to the Holy Roman Emperor for backing. However, as the merchant classes became more wealthy they grew more organized, with the backing of the Pope, hoping to wrest political power from the Lords and thus control the economic and foreign policy essential for the well being of their trade. As a result, factions evolved in Florence – the Ghibellines under the Holy Roman Emperor and the merchant Guelphs under the Pope. Following decades of struggle, allegiance, vendetta and betrayal the Guelphs established the upper hand in 1250 after the Ghibellines had been thrown off balance by the sudden death of the Holy Roman Emperor, Frederick II. Rapidly, the new order established a government lead by a Podestà, or Captain of the Militia, for whom a new palace was erected – the Palazzo del Popolo or, as we know it today, the Bargello (page 20). Following a brief interlude of Ghibelline rule which ended in 1267, the Guelphs fully established themselves. The population had by this time risen to 45,000 and the tentacles of Florentine trade and banking were spreading all over Europe. The principal trade was wool processing and the manufacturing of cloth. Imports came from as far as Norfolk in England and exports were spread around the Mediterranean basin.

Even though party and family squabbles continued, the overwhelming background of prosperity sustained a building boom. The names of the architects of this period are mostly unknown, but Arnolfo di Cambio was described in a document of 1300 as 'more famous and skilled in the building of churches than anyone else in the region' and several great Florentine buildings have been attributed to him. They include the Palazzo della Signoria (completed 1302, page 86), the Dominican church of Santa Maria Novella (page 112), the Franciscan church of Santa Croce (vastly enlarged 1294, page 97), and the Duomo or Cathedral (started 1294, page 29). All were large public institutions, reflecting a sense of pride, if not determined arrogance, on the part of the new republican government, not to be ousted. Such buildings demanded decoration of the highest quality, and the masterpieces painted for them included Duccio's altarpiece for Santa Maria Novella (page 37) and Giotto's for Ognissanti (page 38), both of which are now in the Uffizi. Private chapels were also

commissioned by wealthy banking families such as the Bardi and the Peruzzi; the wall-paintings in their chapels in Santa Croce (page 98) are thought to be by Giotto. The need to cover large areas of wall to the glorification of God and the edification of the purchasing family without conspicuous flamboyance perhaps led to the widespread use of fresco, a comparatively inexpensive form of decoration when compared to mosaic or panel paintings with gold leaf backgrounds (3,8).

Giotto was one of the greatest figures in the history of art; his convincingly solid and three-dimensional figures broke away from medieval conventions and established the central tradition of European painting. His influence on Florentine art was immense, but the city's flourishing growth of painting, sculpture and architecture faltered in the 1340s because of a failing economy. This was caused partly by the collapse of the Bardi and Peruzzi banks and partly by an outbreak of the Black Death in 1348. Over forty thousand citizens died and in the years following the plague were marked by high labour costs, high transport and raw material costs and depleted markets all around Europe. As if to compensate for a decline in the visual arts, the great literary tradition started by Dante Alighieri was continued by Petrarch and Boccaccio. These three created the Italian literary language, writing in the dialect of their native Tuscany rather than in Latin, which had previously been the accepted language for serious literary composition.

ROMAN AND MEDIEVAL TOWN PLANNING

Florence was founded in Roman times. The city was of some size and importance, with major buildings including baths, a theatre and an amphitheatre. Only a few traces remain of Roman structures (mostly out of sight), but the heart of the city still bears the imprint of the grid plan that was typical of Roman times. The centre of the Roman town was the forum, where people met to do business and to socialize. Its site in

Florence is now occupied by the Piazza della Repubblica, which is still the hub of the city. The Romans built a bridge on the place where the Ponte Vecchio (old bridge) now stands, and this was the only link with the other side of the river Arno until the Ponte Nuova (new bridge) was built 1218–20. The Roman city was entirely north of the Arno and the walls surrounding it formed a regular rectangle. With a few

3. MASOLINO, DETAIL FROM *THE HEALING OF THE LAME AND THE RESURRECTION OF TABITHA*, c. 1425, BRANCACCI CHAPEL, SANTA MARIA DEL CARMINE (IN THE BACKGROUND IS A VIEW OF FLORENCE)

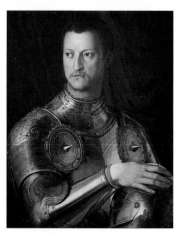

4. Agnolo Bronzino,
*duke Cosimo I de' medici
in Armour*, c. 1545 (Uffizi)

The organization of the government of Florence into a Republic based on Roman Law became formalized in the fourteenth century. The overriding principle was that no individual should be allowed to become too powerful, so a number of safeguards were built into the system. For example, the Gonfalonier (standard bearer) of Justice and his executive committee of eight priors held their posts for only two months. Thereafter they

exceptions, this perimeter was followed by the the earliest medieval walls, built in the seventh century. However, later medieval walls became more irregular in plan, following the much less rigid and systematic way in which medieval towns developed. Unlike Roman towns, they grew and expanded piecemeal rather than being carefully planned. To the west of the via Tornabuoni, the streets focus on single points, creating odd wedge-shaped buildings and a star-like street plan. The walls begun in 1172 included for the first time an area south of the river. The final walls, built in the thirteenth and fourteenth centuries, enclosed a much larger area to the north, following the line of the modern boulevards (*circonvallazione*). Several gates for this wall survive.

The location of some of the city's most important churches reflects the medieval growth of Florence. Santa Croce (the major church of the Franciscan Order) and Santa Maria Novella (the major church of the Dominican Order) were established in the thirteenth century, outside the twelfth-century walls. Because they were outside the walls they could be built on the large scale needed to fulfil the evangelical mission of these Orders, preaching to the rapidly expanding population. The Franciscans aimed to make their preaching accessible to all, reflecting St. Francis's view that everyone is equal before God. Thus the Franciscans tended to site themselves in the poor areas, and Santa Croce is situated where the poorly paid dye casters lived. By contrast, Domincan theology appealed to the educated middle classes, thus in Florence, as in other cities, their church is set in the more expensive end of town.

could not be re-elected for three years. Legislation had to go in front of other committees before it was presented to a large voting council of five hundred who were made up of responsible guild members. Thus the exclusive interests of the guilds lay at the heart of government thinking and the pursuit of power by any individual was its scourge. By the late fourteenth century, guilds were responsible for the maintenance of large institutions and collectively they patronized the church of Orsanmichele (page 69), appropriately sited on the thoroughfare between the centre of government, the Palazzo Signoria, and the spiritual heart of the city, the Cathedral.

Florence's most glorious cultural period – the fifteenth century – came after a time of political crisis. In the 1390s Giangaleazzo Visconti, Duke of Milan, had been pursuing an expansionist policy throughout Northern Italy. Having silenced Pisa and annexed Bologna, he focused on Florence, which bravely sought to defend its republican principles. It must have seemed like a miracle when Visconti died from plague outside the walls of the city in 1402: for all their bravado, the Florentines could not have imagined themselves a military match for him. Neighbouring cities, like Pisa, that had been made weak by Visconti's campaign, were now soft targets for Florentine expansionism. By 1406 Florence had control of her sea route through Pisa and thus one of the stumbling blocks to the expansion of trade had been removed. Looking back over a century of social, political and economic upheaval, the Florentines could reflect that barring two brief interruptions of autocracy, they alone in Italy had survived as a free Republic with its economy intact. It must have been tempting to think that God favoured Florence and the exultant sense of civic pride had far-reaching consequences on state patronage in the first two decades of the fifteenth century.

With vigorous enthusiasm Florence celebrated its proud history with a number of large public works administered by specific guilds. In 1401, for example, the Arte della Calimala (the guild of refiners of imported woollen cloth) supervised a competition for a set of bronze doors for the beloved Baptistery. Seven sculptors competed and the commission was awarded to Lorenzo Ghiberti, who worked on the doors from 1403 to 1424 (page 26). While he was engaged on this commission Ghiberti also made

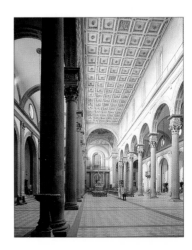

5. THE NAVE OF SAN LORENZO

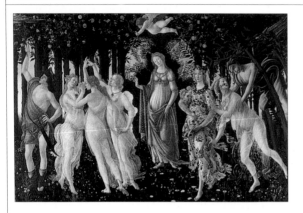

6. Sandro Botticelli, *Primavera*, c. 1478 (Uffizi)

In its broadest sense, the word 'humanism' describes an outlook on life or a system of thought that is concerned with human rather than divine or supernatural matters. When the word is spelt with a capital H, however, it refers specifically to an aspect of Renaissance culture that was marked by a turning away from medieval systems of thought (which were based on theology) to an outlook that particularly valued the human achievement of the language, literature and antiquities of ancient Rome (later of ancient Greece, too). The Latin language formed a direct link with ancient Rome, for it had never died as a written and spoken means of communication. It was the language of the Church and for centuries of virtually all serious writing. The manuscripts of Roman authors were carefully preserved and copied during the Middle Ages, usually in the libraries of monasteries (although many perished accidentally or at the hands of barbarians). They were valued as historical documents, but it was only during the Renaissance that scholars began to study them with a view to building up sympathy with the Roman mind. The Humanists perceived that the achievements of the Romans in many spheres of life were great and they aimed to combine the best of ancient thought with the traditions of Christianity. Humanism began in Italy (with Florence as one of its main centres), and spread throughout Europe. Italians naturally felt the closest kinship with the Romans, as they inhabited the same land. Scholars began to glimpse the achievements of the ancient Greeks behind those of the Romans and eventually the Greek language, too, was closely studied. Latin, however, remained of more central importance, for it was the language in which scholars wrote and spoke, whereas Greek was a 'dead' language. It was a matter of pride among Humanists to have a graceful Latin style. In the visual arts, Humanism was influential in promoting an interest in Classical subject matter. Botticelli was the first great painter to treat mythological subjects with the seriousness traditionally reserved for religious themes. His *Primavera* (6) was probably painted for the Humanist Lorenzo di Pierfrancesco de' Medici.

important sculpture for the church of Orsanmichele, where niches on the exterior were filled with larger-than-lifesize statues of the patron saints of the guilds (pages 69, 25). Donatello also contributed to this scheme. Another great contemporary was Filippo Brunelleschi, who was among the sculptors defeated by Ghiberti in the Baptistery competition. The disappointment of losing is said to have led him to turn to architecture, and in this field he became much more famous than as a sculptor, above all as the designer of the dome of the cathedral (begun 1420), the supreme visual symbol of Florence. Slightly earlier, in his *In Praise of the City of Florence* (written 1403–04) the humanist scholar and politician Leonardo Bruni had expressed the Florentines' pride in their beauty of their city – a beauty that was now being greatly enhanced: 'Once people have actually seen

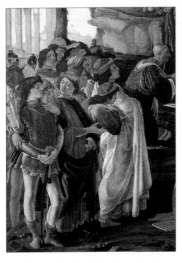

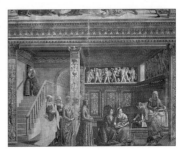

8. (ABOVE) DOMENICO GHIRLANDAIO, *THE BIRTH OF THE VIRGIN* (DETAIL FROM SANTA MARIA NOVELLA), 1486–90
7. (LEFT) SANDRO BOTTICELLI, *ADORATION OF THE MAGI* (DETAIL SHOWING MEMBERS OF THE MEDICI FAMILY), 1472–75 (UFFIZI)

Florence... her great mass of architecture and the grandeur of her buildings, her splendour and magnificence, the tall towers, the marble churches, the domes of the basilicas, the splendid palaces, the turreted walls and the numerous villas, her charm, beauty and decor ... they are no longer amazed at her achievements.'

The greatest painter of this period was Masaccio, whose extraordinary achievements were compressed into a life of only twenty-seven years. He was the first painter to show a consistent mastery of perspective and he succeeded in creating a new sense of three-dimensional solidity on the two-dimensional surface of wall or panel. Like his friend Donatello, he was interested in the construction of figures rather than in surface detail and like Donatello he excelled in the depiction of human feelings with great vigour and directness. The architect Brunelleschi was also a friend of Donatello and Masaccio and these three were the giants of a remarkable generation who created the Renaissance style. Other members of the same generation included Fra Angelico, Luca della Robbia and Uccello. Rarely can one city have boasted such a galaxy of talent.

In this period Florence was also notable for a family of patrons whose name is as famous as those of the great artists they employed – the Medici. This family of bankers and merchants founded a dynasty that in effect ruled

Florence (and later all of Tuscany) for most of the period between 1434 and 1737. Giovanni de Bicci de' Medici (1360–1429) who founded the bank was a modest man who kept a low profile in the political life of the city. On his death the business was passed onto his son, Cosimo (1389–1464), under whose leadership the bank became a network of twenty-two branches spreading from London to Naples. He too kept a low profile in politics, being gonfalonier only once. However, he did control the largest party of supporters and the populace liked him because he was not obviously extravagant and much of his patronage of the arts, as at San Marco (page 107) and San Lorenzo (page 103) benefited the public. Under Cosimo the Medici became bankers to the Papacy. In 1433 Cosimo was exiled following a plot by the Strozzi, Brancacci and Abizzi families, who complained bitterly that he wielded too much power. Cosimo's guidance and the stability that his bank gave to the city were greatly missed by the Florentines, however, and a year later he returned in triumph.

The most famous member of the Medici family was Cosimo's grandson Lorenzo (1449–92), known as Lorenzo the Magnificent. He was the first patron of Michelangelo, but his collecting interests seem to have been mainly in ancient gems and coins rather than in painting or sculpture. It was Lorenzo's second cousin, Lorenzo di Pierfrancesco de' Medici, who evidently commissioned the works that now seem the essence of the Renaissance, Botticelli's paintings *The Birth of Venus* (page 44) and *Primavera* (6). Their graceful beauty puts them among the great masterpieces of all time, but in the 1490s his style changed, expressing an intense spirituality. Botticelli was possibly influenced at this time by Girolamo Savonarola, a Dominican friar whose thundering sermons for a time won him a huge public following. He advocated austerity and poured scorn on the acquisitive nature of Florentine society. In 1498, however, he was seized by a mob, tortured and executed as a heretic (9).

Meanwhile, Lorenzo the Magnificent had died in 1492 and his son Piero fled the city two years later during the troubled time of Savonarola. The city once more was a republic and once again there was pride in Florence

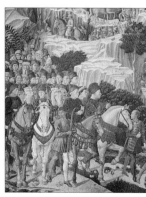

9. ANON., THE BURNING OF SAVONAROLA, 1498 (MUSEO DI FIRENZE COM'ERA)

10, BENOZZO GOZZOLI, *THE PROCESSION OF THE MAGI* (DETAIL), (PALAZZO MEDICI-RICCARDI), 1459–60

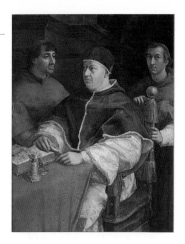
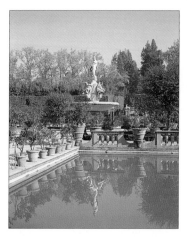

11. RAPHAEL, *PORTRAIT OF POPE LEO X*,
C. 1517 (UFFIZI)

12. THE BOBOLI GARDENS

as a just and fair state of limitless capacity. Michelangelo's great statue *David*, carved in 1501–04 (page 33), is the most famous visual symbol of the new republic, and Michelangelo and Leonardo da Vinci – the city's two greatest artists – also worked on huge murals for the Palazzo Vecchio. Unfortunately both paintings were abandoned, as Michelangelo left for Rome in 1505 and Leonardo for Milan in 1506. Under Pope Julius II Rome was beginning to take over from Florence as the leading centre of patronage in Italy, but Florence could still boast artists of the calibre of Andrea del Sarto and Fra Bartolommeo.

The Medici returned to power in Florence in 1512 and Lorenzo the Magnificent's son Giovanni and his nephew Giulio became pope as Leo X (1513–21) and Clement VII (1523–34). Papal patronage dominated Florentine art at this time; Leo X, for example (11), made Michelangelo drop his work on the tomb of Julius II (page 34) to design a facade for San Lorenzo (5). His design was never built, but the model for it can be seen at the Casa Buonarroti (page 28). Michelangelo also began work on a mortuary chapel for the family – the Medici Chapel – in San Lorenzo in 1520. In 1527–30 the Medici had another period of exile, but then returned to assume near absolute control. Michelangelo had supported the republic of 1527–30 and designed defences for the city against the Medici forces. He was pardoned by the Medici and returned to work on the mortuary chapel, but he left it unfinished in 1534, when he left to settle in Rome.

The major Medici patron of the sixteenth century was Cosimo I (1519–74), who was Duke of Florence from 1537 to 1569, then became the first Grand Duke of Tuscany. He defeated Siena and Pisa early in his reign and dispensed with the last vestiges of republicanism. As a patron of the arts his aim was to create propaganda, glorifying himself as head of State and celebrating the illustrious fifteenth-century history of the Medici. His right-hand-man in artistic affairs was Giorgio Vasari, painter, architect (the Uffizi is his finest building) and author of *The Lives of the Artists* (1550, revised edition 1568), a book that has won him the reputation as the father of art history. All around Florence there are busts of Cosimo

attached to buildings and above doorways and in painted portraits he was immortalized by Bronzino (4).

Under subsequent Medici leadership Florence gradually lost ground in terms of European importance. Competion from other manufacturing centres had diminished Florentine trade and her distance from the sea meant that Genoa and Naples could take better advantage of the new trade routes to the Americas and the Far East. Major artists were still attracted to the city in the seventeenth century, notably Pietro da Cortona, who carried out superb decorations at the Pitti Palace (13), but its heyday was now long past. Rome was now the focus of creative art and Florence was already assuming a role as a tourist attraction.

In the eighteenth century the city moved by marriage into the possession of first the Austrian and then the French royal households. In 1860 Tuscany became part of the newly united Italy and Florence was the kingdom's capital from 1861 to 1875. Considerable damage was suffered during the Second World War and much more during the flood of the River Arno in 1966. The fact that this was regarded as an international cultural disaster and not just a local affair is a good indication of the leading place that Florence occupies in the hearts of art lovers throughout the world.

13. (ABOVE) *THE PITTI PALACE*, ATTRIBUTED TO JUSTUS VAN UTENS (MUSEO DI FIRENZE COM'ERA

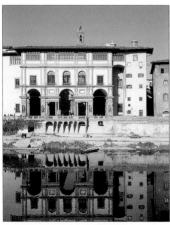

14. (LEFT) THE UFFIZI GALLERY AND THE RIVER ARNO

There is a long and venerable tradition of restoration in Florence, and the restorer is generally regarded there as someone who needs artistic sensitivity as well as scientific skills. There are ethical conundrums involved in restoration, as well as scientific and artistic problems. Most arguments centre round whether the restorer should preserve what remains of a painting (making any additions known to the viewer) or attempt to restore it to its original appearance. The 'before and after' illustrations of Masaccio's *Adam and Eve* from the recently restored Brancacci Chapel show how striking the results of restoration can be. Masaccio depicted Adam without a fig leaf, but one was added in the more prudish climate of the seventeenth century. The addition was a reflection of an age and a sensibility long past, so the fig leaf has been removed. When old overpaint such as this is cleaned off,

there are sometimes areas where no original paint is left, so touching up may be necessary. One of the principles that is generally regarded as fundamental to restoration is that nothing should be added in this way that cannot be later removed. Elsewhere in the Brancacci Chapel, particularly facing the altar on the left it is possible to see a restoration technique called *tratteggio* whereby hundreds of tiny multicoloured lines are painted to mimic the tone of lost pigment. These lines are visible when the painting is seen close up, but at a normal viewing distance they cannot be seen. The intention is that repair should neither disfigure nor mislead. The Cimabue *Crucifix* at Santa Croce (page 100), so badly damaged in the 1966 flood, illustrates another technique, *sotto tono*, in which a flat blank tone is clearly visible. Both methods retain the painting's integrity and avoid *mimetica*, or mimicry.

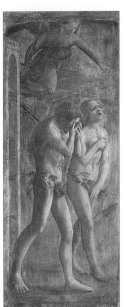 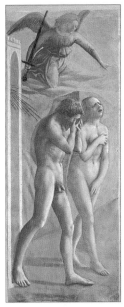

15 AND 16. MASACCIO, *THE EXPULSION OF ADAM AND EVE FROM PARADISE*, c. 1425, BRANCACCI CHAPEL, SANTA MARIA DEL CARMINE (THE VERSION ON THE LEFT IS BEFORE AND THAT ON THE RIGHT IS AFTER RESTORATION.)

ART

IN

FOCUS

Museums

Paintings

Applied Arts

Architecture

THE BAPTISTERY

Built 11th or 12th century

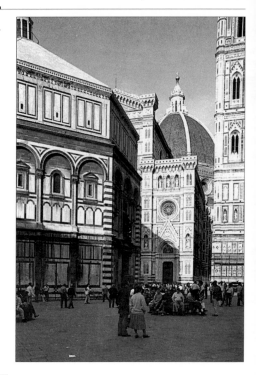

Address
Piazza S Giovanni, Firenze
50129.
✆ (1) 52 17 70

Map reference
①

Opening times
Daily 1–6.

St. John the Baptist is the patron saint of Florence, and the Baptistery dedicated to him is of great importance in the city. The early history of the building is unclear but originally it was thought to stand on the foundations of a Roman temple dedicated to Mars, although today scholars agree that the structure dates from the sixth or seventh centuries. The green and white marble exterior dates from the eleventh or twelfth century and its design became the source for many architectural schemes during the Renaissance. Inside there is a spectacular octagonal dome covered with a mosaic from *c.* 1225, which depicts a gruesome *Last Judgment.* Bands of decoration illustrating the Old and New Testaments and the life of St. John the Baptist. To the right of the altar Donatello and Michelozzo designed the tomb of Pope John XXIII, under whose Papacy the Medici became the papal bankers. Pope John was deposed for corruption and philandering but lived out his life under the protection of the Medici.

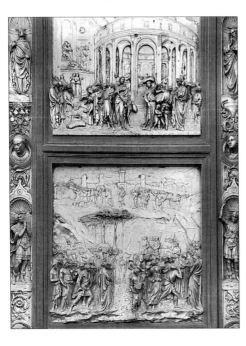

Lorenzo Ghiberti (1378–1455) was first commissioned to make the bronze doors on the North side of the Baptistery in 1403; he finally finished them in 1424. Immediately afterwards he was engaged in a further twenty-seven year project for the Eastern doors facing the Duomo. They are popularly known as the *Gate of Paradise*, a phrase uttered by Michelangelo as he stood before them, transfixed. Consisting of ten panels illustrating Old Testament scenes, Ghiberti made a radical break in format and style from his previous doors. The use of rectangular frames instead of decorative quatrefoils lends emphasis to the narrative, and Renaissance developments in the use of perspective are fully employed here. This second set of doors fully illustrate the strides made in realism and the influence upon Ghiberti of Donatello and Masaccio. Reading down the doors the top level depicts *The Creation* and the *Story of Cain and Abel* followed below by *The Drunkenness of Noah* and *The Sacrifice of Isaac, Esau and Jacob*. Opposite are *Joseph sold into Slavery*, *Moses and the Tablets*, *The Fall of Jericho*, *The Battle with the Philistine* and *Solomon and the Queen of Sheba*. These doors and, indeed, the whole building were the responsibility of Arte di Calimala, the Cloth Merchants Guild, the most important guild in the city. Owing to pollution, the original panels have been regilded and are on display in Museo dell'Opera del Duomo (page 61); those seen at the Baptistery are good copies.

Address

Piazza San Firenze, Firenze
50122
© (1) 23885

Map reference
②

Opening times

Daily 9–2.
Closed Mon.

Entrance fee

L 6,000.
Ticket sales stop thirty
minutes before closing.

The Bargello houses the National Museum of Sculpture made up of sculpture and works of applied art which were moved here from the Uffizi in 1859. In the ground floor hall most of the sixteenth-century sculpture is exhibited including works by Michelangelo, Sansovino, Cellini, Giambologna and Ammannati. Outside in the courtyard there are further late Renaissance and Baroque works, and at the top of the exterior staircase there is an enchanting collection of bronze birds. The Great Hall houses some memorable works of the Renaissance. There are a number of Donatellos and some excellent portrait busts by Desiderio da Settignano, amongst others. In other rooms there is a notable collection of decorative arts: a fine array of Venetian glass and an inspiring display of maiolica. One of Italy's most important collections of small bronzes is found on the second floor, most notably Verrocchio's *David* together with a fine assembly of fifteenth-century medals including some by Pisanello. The Franchetti collection of fabrics and the Ressmann armour collection is also found on this floor.

The Bargello was built *c.* 1250 by 'Lapo', Master of Arnolfo di Cambio, as the Palazzo del Popolo, and it became the seat of the Capitano del Popolo who held office as governor of the city for one year. Later it became known as the Podestà, and served as the principal judicial post in the city; the elaborate coats of arms set into the walls of the courtyard represent those who held the post. Throughout the years the Bargello was used as a prison and executions took place in its courtyard or from its windows. Paintings of bankrupts were put up outside the building to warn others of disreputable business men and the streets all around reflect the building's purpose. The Via de'Neri, for example, is named after the black-hooded attendants of the condemned. The Via Condotta, still lined with stationers, was once called the Via dei Librai because the scribes and tradesmen who supplied the courts were based there.

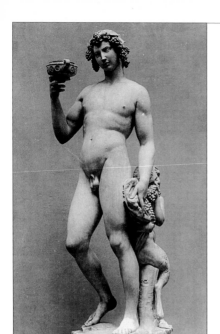

Bacchus is an early sculpture by Michelangelo (1475–1564), depicting the god of wine having drunk too much, forever frozen in mid-sway. The grapes around his head are a clue as to his identity, as is the attendant satyr who scoffs the spare fruit tumbling from a leopard skin pouch. The tree stump and the satyr also serve to support the structure of the statue.

Michelangelo was lucky with his training, for his father, a middle ranking government official, secured him an apprenticeship at the Ghirlandaio workshop. Within a year he had been noticed and asked to join the Medici court of Lorenzo the Magnificent, where he sat at the feet of great thinkers. Michelangelo's education allowed him to depict stories and themes with the sophisticated interpretation of an artist rather than an artisan.

This sculpture was made for the banker Jacopo Galli in Rome around 1496–7, and kept as a garden statue for fifty years before it was bought by the Medici. Michelangelo had recently arrived in Rome when he sculpted it, after possibly escaping the turmoil of Savonarola's purge on materialism in Florence. When he saw large-scale Roman buildings and sculpture for the first time the effect must have been overwhelming; although the Medici collected antiquities, it was not until much later that patrons could overcome the logistical problems of moving larger sculpture outside Rome. The bulk and size of *Bacchus* outstrips the scale of any sculpture Michelangelo had completed to date, and so impressed were some at his assimilation of the antique that, on occasions, they confused his sculpture with original Roman statues. In the Renaissance, for a work to be compared to the antique was considered a tremendous accolade.

Leda and the Swan

c. 1540–50

Bartolomeo Ammannati (attributed)

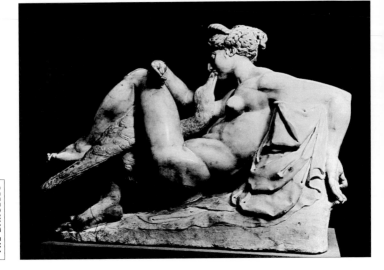

'A sudden blow: the great wings beating still
Above the staggering girl, her thighs caressed
By the dark webs, her nape caught in his bill,
He holds her helpless breast upon his breast.'

So W. B. Yeats describes the bizarre horror of this lewd episode in mythology, the rape of Leda by Zeus, king of the gods, posing as a swan. Subsequently, Leda lays two eggs from which hatch two sets of twins. This is one of a series of rapes of mortals committed by Zeus, in which he assumes different guises. The episode is related in Ovid's *Metamorphoses*; sculptures like this were popular with court society in the sixteenth century where the sophisticated and educated would have appreciated their sources in Classical literature.

Ammannati was a follower of Michelangelo and at the Laurentian library helped Vasari to realize the plans of his master. This sculpture is a copy *c.* 1540–50 of a picture by Michelangelo commissioned by Alfonso d'Este in the 1540s, which has sadly been destroyed. As an independent artist Ammannati was responsible for the *Neptune* in the Piazza Signoria and the extension to the Palazzo Pitti. Ironically, he was greatly influenced by the Counter-Reformation and published a significant letter in 1582 about the responsibility of the sculptor towards public decency. This letter asked permission for some of his earlier works to be destroyed, but the request was not granted.

Giambologna
(Giovanni
Bologna)

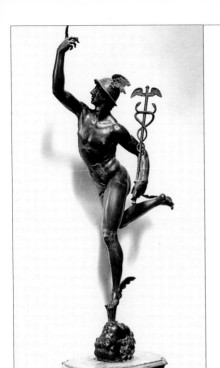

THE BARGELLO

Mercury was the messenger god, and here Giambologna (1529–1608) has shown him in full flight about his business. Like so much of Giambologna's work, this is a virtuoso display of technical skill in that the whole sculpture balances on one solidified gust of air. In common with other works such as the *Rape of a Sabine* in the Loggia dei Lanzi (page 91), this sculpture strikes at the heart of the theme of movement and agility.

Giambologna came to Florence after working in Rome, and was soon made the court sculptor to the Medici in the mid-sixteenth century. From his large workshop on the Borg Pinti he piled out smaller bronzes for diplomatic presents. Mercury was also the mythological god of eloquence and his dual role meant that bronze statuettes representing him were ideal presents for travelling ambassadors to give to their hosts. Diplomacy became increasingly important during the sixteenth century as improved ballistics and effective canonry made war a more terrifying prospect. Deterrence and the ability to talk around war became essential elements of state craft, particularly for a small dukedom like Tuscany. In a world where symbolism and nuance carried the weight of brute force, the role of artists like Giambologna became more significant and thus their status rose. The sculptor was commissioned by many notable heads of state including two Holy Roman Emperors, the Elector of Saxony and several Popes. In 1588 he was awarded his own coat of arms and in 1599 he was made a Knight of the Order of Christ by Clement VIII, a distinction which Michelangelo had once held.

A Turkey

Before 1567

Giambologna
(Giovanni Bologna)

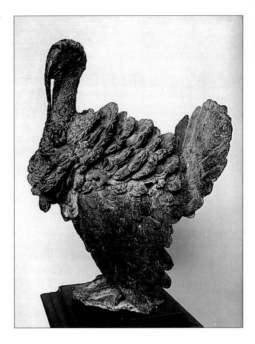

This *Turkey* by Giambologna (1529–1608) is part of a collection of birds originally displayed in the garden grotto at the Medici Villa at Castello, where they were recorded in 1567. The *Turkey* in particular displays Giambologna's skill in the use of the lost wax technique of bronze casting. Through the hole in the body of the bird one can see the lump core around which a wax slip was modelled to form the present shape of the bird. The wax would then be cased in clay leaving ducts for 'run off' and an aperture at the top. Into this hole liquid bronze was poured which, by virtue of its intense heat melted the wax, allowing it to run off through the ducts provided. Once cool, the clay mould was broken and the remaining figure was polished and finished. The *Turkey*, perhaps more than any other sculpture in Florence, best illustrates the problems faced in casting bronze. Accidental bubbles of air in the cast could leave gaping holes in the bronze, rendering the formal sculpture flawed. Should this happen, and it frequently did, the sculptor would have to start again. That the *Turkey* has holes is no indictment of Giambologna but inevitable given the potential air traps presented by the tucks and grooves of a turkey's plumage. Aside from the technical skill involved in representing these birds, Giambologna displays great sensitivity in capturing the pompous dignity of the turkey, the menacing glare of an eagle, the empty headed strut of the peacock and the wizened stare of the owl.

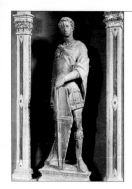

St. George

c. 1415

Donatello
(Donato di Betto
Bardi)

St. George, set here in the original decorated Gothic frame, was the patron saint of the Armourers Guild in Florence. Until the end of the nineteenth century this statue stood with other monuments to the guilds of Florence around the niches in the exterior of Orsanmichele but it is now displayed in the Salone del Consiglio Generale (Great Hall) on the first floor. Richer guilds employed established sculptors to cast costly bronze saints but the armourers called on Donatello (*c.* 1386–1466), a young innovative sculptor to work in less expensive marble. Compared to contemporary bronze figures, Donatello's hero has no stylistic links with the elegant, decorative forms of Gothic sculpture. St. George is static, solid and real with the set expression of a knowing warrior He once carried a sword in his hand and he would have worn a helmet.

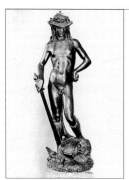

David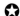

1408–16

Donatello
(Donato di Betto
Bardi)

David by Donatello (*c.* 1386–1466) has provoked more comment than most free-standing bronze sculptures of the fifteenth century. Unlike his heroic *St. George* (see above) or Michelangelo's manly *David* (page 33), this is a seemingly effeminate image, as David stands in an almost petulant pose with hand on hip in elegant *contrapposto*. In terms of the story, however, Donatello has been more accurate than Michelangelo. David was a twelve-year-old shepherd whose puny stature next the the giant Goliath is the dramatic and moral point of the story. Donatello was commissioned by Cosimo de'Medici *c.* 1440 to make this statue. It was the first free-standing male nude since antiquity, and it stood until 1494 in the main courtyard of the Palazzo Medici, when it was moved to the Palazzo Signoria.

Competition pieces
for the Baptistery Doors

c. 1401

Lorenzo Ghiberti &
Filippo Brunelleschi

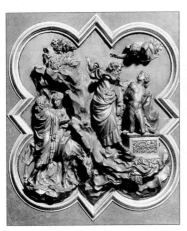
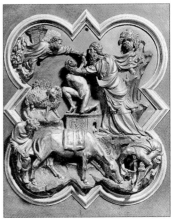

In 1401 the Cloth Merchants Guild, who were responsible for the maintenance and decoration of the Baptistery, invited entries for a competition to decide who should cast the North doors. The new doors were to depict scenes from the New Testament but, for the purposes of the competition, the narrative chosen was the dramatic Old Testament story when Abraham, as a test of his obedience to God, was told to sacrifice his son Isaac. He was instructed to take Isaac, together with two shepherds and a ram, to an altar high on a mountain. He left the shepherds below while he continued alone with Isaac. At the last instant before Abraham cut his son's throat, an angel appeared to seize his hand. Both Brunelleschi (1377–1446) and Ghiberti (1378–1455) submitted entries, which are displayed side by side. Ghiberti won the competition, and it is generally agreed that his competition piece (above left) shows a greater sense of drama than Brunelleschi's (above right). In addition, the composition of Ghiberti's panel is more clear in that the rocks, signifying that Abraham has left the shepherds down the mountain, divide the narrative and set up two diagonals from the shepherds to the angel and from bottom right to top left. Ghiberti may also have been chosen because his proposition saved money. It weighed one quarter less than Brunelleschi's and was made in fewer parts which, given the complexity of bronze casting, was a significant consideration.

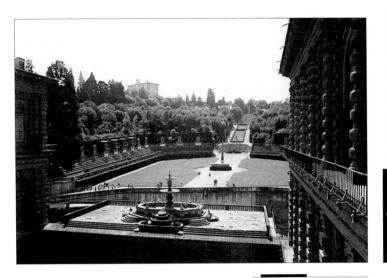

When the Medici acquired the Palazzo Pitti in 1549 they also bought land on the hillside behind it from among other families, the Bogolini, from which we derive the name Boboli. The gardens were initially laid out under Cosimo de'Medici, but were extended in the early seventeenth century. A large amphitheatre built by Ammannati (1511–92) lies immediately behind the palace; it was used for impressive court entertainments. Above this is a pond dedicated to Neptune and at the top of the hill a statue of *Abundance* by Giambologna. To the right of this is a beautiful cypress avenue leading to an island pond, and to the left is an eighteenth-century coffee house which still has a bar. At the top is the Forte Belvedere, built in the sixteenth century, which can be explored freely. Towards the exit there is a grotto by Buontalenti built for Eleonora, wife of Cosimo I, which houses copies of Michelangelo's *Slaves*, now in the Accademia. By the gate is a curious statue of a dwarf on a tortoise by Valerio Cioli (1560). He was the favourite dwarf of Cosimo I and was nicknamed *Morgante* after a giant in a poem by Luigi Pulci.

Address
Palazzo Pitti,
Piazza Pitti, Firenze 50125.

Map reference
 ③

Opening times
June, July, Aug: 9:30–7:30.
April, May, Sept: 9:30–6:30.
March, Oct: 9:30–5:30.
Nov, Feb: 9:30–4:30.

Entrance fee
L 5,000.

Address
Via Ghibellina, 70, Firenze.
✆ (1) 24 17 52

Map reference
④

Opening times
Daily 9.30–1.30 Closed Tue.

Entrance fee
L8000.

Michelangelo's original studio was in the Via Mozza but in 1508 he bought bought three houses near Santa Croce which his nephew and heir Leonardo Buonarroti joined together to form the present palace. Leonardo was not a talented man but he was astute. By giving his uncle's *Victory*, now in the Palazzo Vecchio, and the celebrated *Slaves* at the Accademia to Cosimo I, he secured himself a court position and the long term future of his family. His son, Michelangelo the Younger, enjoyed the lifestyle of an art collector, amateur scientist and decorative scheme designer for the Medici court. One design was the ceiling decoration for the Palatine Gallery in the Palazzo Pitti, painted by Pietro da Cortona. In the 1630s Michelangelo the Younger laid the Casa Buonarroti out as a shrine to his great uncle's memory. The Galleria is decorated with seventeenth-century pictures extolling the virtues of Michelangelo and illustrating the occasions on which he met Popes, Kings and Emperors. Other rooms, the room of Night and Day, for example, display the Buonarroti coat of arms emblazoned with the arms of noble families by marriage. In the chapel there is a wonderful painting of an old man by Guido Reni and beyond this is a room not dissimilar in function to the Tribuna in the Uffizi. It is a *Wunderkammer* and was used to display fine sculpture, curious geological specimens, flora and fauna. Such rooms are a testament to the seventeenth-century polyglot mind, and this palace is a rare survival of seventeenth-century interior decoration on a modest scale. Over the years the museum has acquired some significant works from Michelangelo's career. Of special interest is the model for the facade of San Lorenzo which was commissioned by Leo X, the first Medici Pope, but never executed. There is a full scale plaster study for a river god that was to be one of four to accompany Dawn, Dusk, Night and Day in the New Sacristy, and two early reliefs, the *Madonna della Scala* and the *Battle of the Centaurs*.

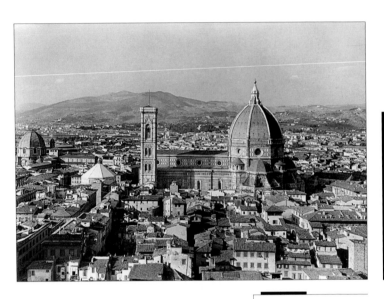

The laying of the Cathedral foundations by Arnolfo di Cambio (*c.* 1245–1302) in 1294 coincided with much building around the city; the Palazzo Vecchio, Santa Croce and Santa Maria Novella all date from this time, which gives an indication of the civic pride and wealth of the merchants of Florence. Though not at the beginning, the responsibility for the site fell to the Arte della Lana, or Wool Merchants Guild, and in 1331 they engaged Giotto, the best known Tuscan painter of the day, as site manager. Under his influence the Campanile was begun and later Andrea Pisano finished off the reliefs. Work continued slowly on the main building until 1417 when the drum was finished and Brunelleschi's plan for the great Dome was taken up. Curiously, the facade was never completed and it was only in the nineteenth century that the limited old structure was torn down and replaced. Halfway along the nave, stairs lead down to the remains of the sixth- or seventh-century church of Santa Reparata, which was uncovered 1965–74.

Address
Piazza del Duomo
Firenze 50129

Map reference

Opening times
Cathedral: Daily 9:30–6:00.
Dome: Daily 10:00–5:40.
Last sale of tickets: 5.00

Entrance fee
L 3,000.

✪ The Cathedral Dome

1420–1436

Filippo Brunelleschi

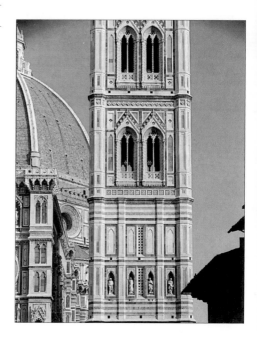

When built this was the largest known dome at ninety-one metres high and forty-five-and-a-half metres in diameter. Nothing like it had been attempted since antiquity, and today engineers still wonder at how precisely the structure works. The intention to build on this scale must have been envisaged from the time that the foundations were laid. The dome's projected appearance can be seen clearly in the Bonaiuto's picture of the *Church Militant and Triumphant* at the Spanish Chapel in the Chiostro Verde (page 117) at Santa Maria Novella, which dates from 1366. A significant problem was how to avoid the immense costs of scaffolding such a colossal space, which would hold the centring for the eight outer ribs of the structure. The solution Brunelleschi (1377–1446) devised was to build an inner dome of interlocking herring bone bricks which, level by level, formed a secure base into which scaffolding poles were cantilevered. Once in place the new level of scaffolding was used to build the next layers of brick inner dome which in turn formed the centring support for the outer eight ribs. In recent years the original scaffolding holes were put to good use in order that restorers could clean the fresco decoration of the *Last Judgment* by Federico Zuccari and Vasari.

The structure of the dome can be viewed by climbing the 463 steps which lead up one pier, around the inside of the dome at its base and then up between the inner and outer skin to the lantern. In this way it is also possible to view clearly the seven stained glass windows by Ghiberti, Donatello, Uccello and Castagno.

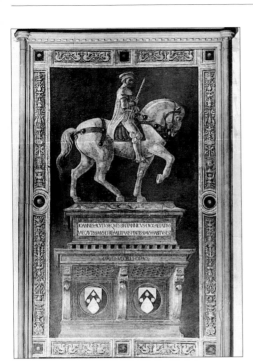

Not to be confused with a similar equestrian monument close by of *Tolentino* by Andrea Castagno, *Sir John Hawkwood* in the north aisle was painted by Uccello (1397–1475) in green monochrome. Uccello's fresco replaced an earlier monument, probably by Agnolo Gaddi, and is painted to resemble marble. This type of equestrian statue which shows the sitter on a high Classical pedestal is based on the well-known Marcus Aurelius monument in Rome, though in this case Hawkwood wears contemporary armour. In 1842 and 1947 this fresco was moved so that today it is not clear at what height the picture should be hung. This problem is exacerbated because there are also two clear viewpoints. The first looks from below at the pedestal while the second viewpoint is centred on the middle of the horse. Uccello was fascinated by the effects of perspective and this is unlikely to have been an error but a was probably a clever device to create depth within the picture by the use of architecture. The second viewpoint avoids an undignified view of the horse's belly and the soles of Hawkwood's feet.

Sir John Hawkwood was awarded the rare distinction of being buried in the Cathedral, a place reserved for national heroes. From humble beginnings as a tailor's apprentice in London, he became a knight for Edward III and then a *condottieri*, or mercenary, fighting for the rich purses offered by squabbling city states of Italy who did not maintain their own standing armies. Hawkwood had fought for the Florentines since 1377 and his loyalty so pleased them that provisions were made for a marble funerary monument even before his death in 1394.

Address

Via Ricasoli, 60

Firenze 50122

 (1) 23 88 5

Map reference

⑥

Opening times

Daily 9–2. Sun 9–2.

Closed Mon.

Entrance fee

L 10,000.

The Galleria dell'Accademia is where Michelangelo's *David* (page 33) has been exhibited since 1882, when De Fabris built a tribune to celebrate the achievements of the Florentine master. The great statue was moved here in 1873 to protect it from the weather and accidents. Previously it had suffered when, in 1527, David's left arm was broken in civic disturbances. The join, performed by Michelangelo, can still be seen. Also in the gallery are the *Slaves* (page 34), a *Pietà* (page 35), and the plaster model for the *Rape of a Sabine* by Giambologna which, unlike the finished version at the Loggia dei Lanzi (page 91), can be seen as it should be, from every angle. The paintings which fill the galleries were given by Pietro Leopoldo I in 1784 and have since been supplemented by works from monasteries and confraternities suppressed during the eighteenth and nineteenth centuries.

There are pictures by many artists from the thirteenth to seventeenth centuries including Lorenzo Monaco, Filippino Lippi, Botticelli, Fra Bartolommeo and Pontormo. These, together with statues and some plaster cast copies of Roman busts, formed the study collection of the Accademia. This school was originally set up by Cosimo I under the auspices of Vasari to replace the painters' brotherhood of St. Luke. The idea was to foster creativity and a national style by providing facilities and ducal patronage. The Accademia was the first state-organized art school which later became a model for other academies in Madrid, Paris and Rome. Ironically, years of devoted study tended to produce artists who, though skilled, did not exhibit the flair of their fifteenth-century compatriots.

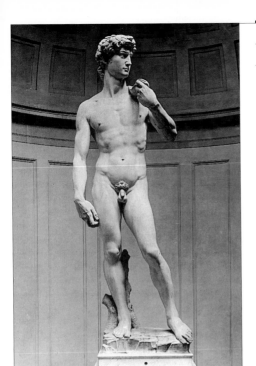

Isolated in the tribune of the Accademia, it is easy to imagine the impact of this sculpture on the people of Florence and the development of art in general. Over four metres high, this was the largest sculpture since antiquity and a bold nude even by the standards of the Renaissance. Michelangelo (1475–1564) was twenty-nine when he finished *David,* and working for the Florentine Republic before he came under the patronage of Pope Julius II in Rome. The marble block, quarried in 1464 and fitfully worked on by Agostino di Duccio and Antonio Rossellino, had been all but abandoned by the Cathedral workshop when it was offered to Michelangelo. He overcame previous workings and a fault between the legs in order to create this symbol of supreme confidence and physical proportion. David's posture, alert gaze and strength are a visual expression of the aspirations of the Republic and for this reason a committee, which included Botticelli, decided to place it outside the front door of the government, the Palazzo Signoria.

As a narrative of the story of David it fails in almost every aspect bar sentiment. David was a twelve-year-old Jewish shepherd, not a fully grown man, who used a single stone tucked out of sight in his right hand, and a sling, which is barely perceptible, to kill the enormous Goliath. Of more importance, however, is the 'idea' of power, cunning, virtue and capability. Michelangelo had created the Florentine equivalent of the Statue of Liberty.

The Slaves

1521–23

Michelangelo Buonarroti

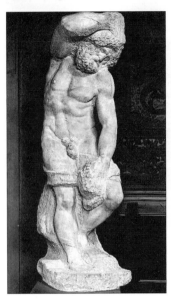 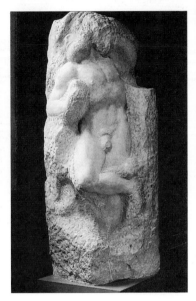

Michelangelo's famous *Slaves* or, as they are sometimes called, *Captives*, were made originally for the tomb of Julius II. This warring Pope and patron of the Sistine Chapel had died in 1513 having planned with Michelangelo (1475–1564) a most splendid tomb to include some forty figures. Successive Popes, most notably Leo X and Clement VII who were both Medici, showed little or no interest in the project, preferring that Michelangelo should work on the Laurentian Library or the New Sacristy. So frustrated was Michelangelo with the project that he described it as a 'tragedy of a sepulchre'. Today parts of it are spread across Europe with two *Slaves* in Paris, the *Victory* in the Palazzo Vecchio and four more *Slaves* here. Sadly, the fate of Julius was not much better; while awaiting his tomb he was interred with his Uncle Sixtus IV but during the Sack of Rome (1527) his remains were violated and scattered. In keeping with this sad tale these four figures seem in a suspended state of struggle never to be properly in their rightful place. Given that they are unfinished and dislocated it is easy to see them as an abstract, almost modern, essay upon the soul captured within the body. This was a metaphysical theme explored by Michelangelo later in both his sculpture and his poetry. The *Slaves* remained in his studio until his death when Leonardo Michelangelo, the old man's nephew, gave them to Cosimo I. From 1585 they remained amongst the lichen covered rocks of Buontalenti's Grotto in the Boboli Gardens (page 27) where copies now take their place.

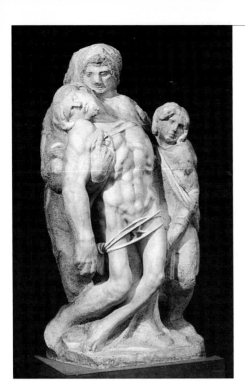

GALLERIA DELL' ACCADEMIA

This is an undocumented work to which scholars are unable to ascribe the name Michelangelo (1475–1564) with any certainty. It is, however, marked up within the Accademia as by him and it certainly deserves comment whoever it may be attributed to. We see here Christ lowered from the cross by two figures, or at least we assume it is Christ even though there are none of the usual symbolic holes in his hands and feet or a wound in his side. The identity of the two figures behind is also difficult to ascertain and the head on the left almost seems to have two faces. In fact, throughout this sculpture there are strange proportions and peculiarities. Were Christ to stand, he would tower over his companions and his legs would probably collapse. Neither this nor the unfinished appearance of the group seem to matter; it is the sentiment which is powerful and everything available has been used to exercise it. The withered and crumpled legs of Christ are pitiful while his loin cloth, by which he barely maintains any dignity, sums up an image of complete abandonment. Further up the body of Christ his lolling neck is enough to make most wince while his broad shoulders and barrel chest invoke a sense of remorse that someone so strong is now dead. The lack of detail in the faces provides no real distraction for the eye from the body of Christ since the sculptor, whoever he may be, brings every element to bear to create an overpowering sense of pity.

(UFFIZI GALLERY)

Address
Loggiato Uffizi,
Piazza degli Uffizi,
Firenze 50122
✆ (1)23885

Map reference
⑦

Opening times
Tues to Sat: 9–7. Sun 9–1.
Closed Mon.
Ticket office closes 45
minutes before gallery
closing.

Entrance fee
L 10,000.

The Uffizi Gallery is the principal art gallery in Florence and presents an unparalleled view of the progression of Florentine painting throughout the Renaissance. Rooms are arranged chronologically making the changes and development of style easy to grasp. The collection has been consistently supplemented so that it now includes many works by North European and Venetian artists. The building also houses a wonderful archive of 50,000 drawings and 60,000 prints from which extracts are regularly taken to form small exhibitions shown on the first floor.

The building was originally commissioned by Cosimo I in 1559, when he asked Giorgio Vasari to purchase the necessary land to build much needed offices for the bureaucracy of the growing state of Tuscany. Indeed, the name Uffizi derives from the Italian *ufficio* (offices).

In 1580 Francesco altered the Loggia in order to incorporate his plans for a public State Gallery and the Medici Collection. The present arrangement of rooms and the daring allowance of space was only made possible by Vasari's innovative use of a cast iron structure running throughout the building, which he adopted because the building is founded on sandy and unsupportive ground. The collection was initially assembled in 1580 by Francesco I, Grand Duke of Tuscany, from paintings in the Palazzo Medici and the Palazzo Vecchio. These were largely from the fifteenth century and included works by Fra Filippo Lippi, Uccello and Botticelli. In 1631 Ferdinando I brought the contents of the Villa Medici from Rome including much famous Greek and Roman sculpture. With the marriage of Ferdinando II more treasures arrived in the dowry of Vittoria della Rovere including the *Venus of Urbino* by Titian, several Raphaels and a Piero della Francesca of the Duke of Urbino. Finally, Anna Maria Ludovica, the last of the Medici dynasty, bequeathed the entire collection to the Florentine people in 1743 having added many of the German and Flemish paintings.

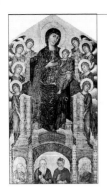

Madonna and Child Enthroned, (Santa Trinità Madonna)

c. 1285

Cimabue (Cenni di Pepi)

Cimabue (1240–1302) was rooted in the Byzantine tradition of painting; Mary is presented as an icon and there is no real attempt at the naturalism associated with later Renaissance works. As such Mary, her attendant angels and the prophets below, appear rather flat with no space around them. Likewise the throne and its supporting architecture display no perspective. It was important, however, that Mary should be lavishly depicted, with a gold surround and gilded lines following the folds of her drapery. Also significant is the role of Jesus, hand raised in benediction as he holds a scroll of the new order as predicted by the prophets below. This was the main altarpiece for the Church of Santa Trinità, an important Vallombrosan monastery for which many works were commissioned.

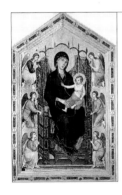

Madonna and Child Enthroned, (The Rucellai Madonna)

1285

Duccio di Buoninsegna

The patrons of this altarpiece were the Compagnia dei Laudesi, a lay confraternity dedicated to charitable works and the most popular of their kind in the city. They had been established by St. Peter the Martyr, a famed Dominican monk, and they had acquired the right to decorate an important chapel at the Dominican church of Santa Maria Novella. Given their status and foundation, this picture by Duccio (c. 1255–c. 1315) speaks volumes about their pride and prestige. It is as expensive as Cimabue's altarpiece (above) but far more naturalistic in style. The throne, for example, shows some attempt at perspective and Mary's robe is not embellished with decorative lines. There are also pointed arches on the throne derived from European Gothic design.

Madonna and Child Enthroned

c. 1310

Giotto di Bondone

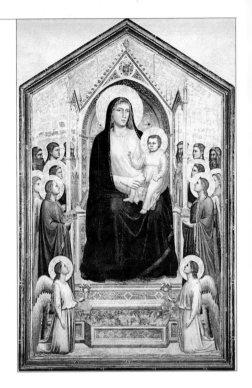

Giotto (1266/7–1337) is largely credited with being the artist who exemplifies the beginning of the Florentine Renaissance. His Madonna has an upright gaze, recognizable facial skin tones and full colourful lips. Throughout there is a tangible sense of space; it is clear that the angels in green are at the front of the throne and that the bearded saint in red stands by the back left-hand corner. This is quite unlike either the Duccio or Cimabue Madonnas (page 37) in which angels are stacked up one on top of the other. Giotto painted this picture for the main altar of Ognissanti (All Saints), a Benedictine institution founded in 1256. As in Cimabue's picture, once at Santa Trinità, there is an evangelical meaning; Jesus carries a scroll for teaching and the four men towards the back of the throne could be Old Testament prophets. In the middle ground one of the angels close to Mary holds a crown referring to her Ascension as Queen of Heaven. To the right, another angel holds a cylindrical pot which may contain one of the gifts from the Three Kings to Christ. Either side of the marble step are two further angels holding vases of lilies and roses, both symbols of the Virgin. The throne which frames Mary and Jesus defines the space in the picture; the pointed trefoil arches and finials are in marked contrast to the Byzantine thrones depicted by both Duccio and Cimabue.

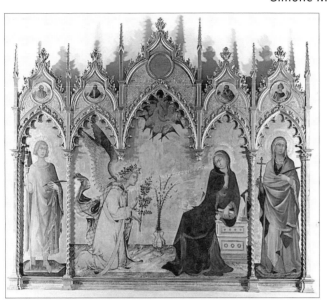

GALLERIA DEGLI UFFIZI

Simone Martini (*c.* 1284–1344) was a pupil of Duccio and, like his master, came from Siena. Until the Black Death, Siena rivalled Florence as an artistic centre fuelled by a buoyant trading and banking economy. This picture was painted for the chapel of Sant'Ansano in Siena Cathedral in 1333 and its flamboyance is a testament to the prestige of the city. The narrative combines well with an elaborate Gothic frame so that the figures of Gabriel and Mary fill individual arches leaving the significant symbols of lilies for purity, the olive branch for peace and the dove for the holy spirit to occupy the middle ground, together with the embossed and gilded words 'Hail thou that art full of grace, the Lord is with thee'. The raised wings and fluttering cloak of the angel give the impression that he has just arrived as Mary recoils in surprise and slight annoyance at his alarming news. Gabriel's steady gaze seems to be insistent while summoning every ounce of tact for his onerous task. On the left stands Sant' Ansano, patron saint of Siena while Santa Giulitta is on the right; both were painted by Simone's brother-in-law Lippo Memmi. Simone's figures have less weight and bulk than those seen in Florentine painting of the same period. This may stem in part from the artist's association with the French court at Naples and therefore the International Gothic style. The characteristics of this style are fine detail and a conspicuous display of skill and expense in order to create highly decorative paintings.

Adoration of the Magi

1423

Gentile da Fabriano

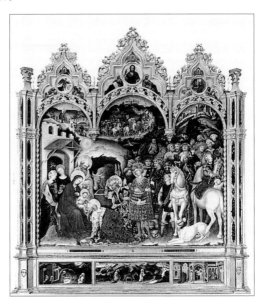

When Onofrio Strozzi died in 1418, his son Palla Strozzi continued the work already started on the family chapel at Santa Trinità by commissioning Gentile da Fabriano (*c.* 1370–1427) to paint this lavish altarpiece. It is signed and dated just above the predella panels which depict the *Nativity*, the *Flight into Egypt* and the *Presentation at the Temple*. The whole painting is surrounded by a frame which is not dissimilar to the elaborate gilded surround of Simone Martini's *Annunciation* of ninety years earlier (page 39). Other aspects of the painting derived from a previous age are the raised gold haloes and spurs of the Magi, together with the disparity of scale of figures arranged according to relative importance.

The narrative starts at the top right, where the Magi are travelling through the countryside to Jerusalem. Time passes and they arrive at Bethlehem in the top left arch, and from there the procession winds its way towards the stable in the foreground. Along the way there are countless incidents: a traveller is mugged by two soldiers, one horse bites another and there are cheaters, hawks and monkeys. In the foreground the oldest Magi adores Jesus while two nurse maids inspect the quality of his present. Just to the right of the youngest Magi are two portraits, one of the dead Onofrio and the other of the patron Palla Strozzi.

After 1474

Piero della Francesca

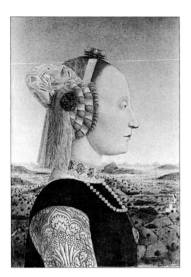 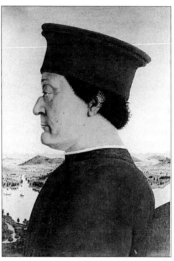

The portrait of Federico da Montefeltro by Piero della Francesca (*c.* 1410–92) is twinned with a portrait of his wife, Battista Sforza. She had died in 1472 while giving birth to their son and heir Guidobaldo, and it seems likely that Federico commissioned these two pictures after her death to commemorate their marriage. For anyone other than his wife, Federico was not a man to tangle with. He was an extraordinarily successful *condottieri*, or mercenary, whose potential involvement in a war occasionally solicited a payment to stay neutral. His imposing appearance was enhanced by the damage to his nose and the loss of his right eye which he suffered at a tournament while celebrating the accession of his brother-in-law, Francesco Sforza, to the dukedom of Milan. Federico was also a great humanist and patron of the arts, spending 30,000 ducats on his library of 1100 books by his death in 1482.

A serenity pervades these portraits which is achieved through the pinpoint accuracy of Piero's painting and his skill at creating tangible space within an aerial perspective. Piero was a master of perspective and wrote two treatises on the subject, one of which he dedicated to Guidobaldo. On the reverse of these pictures there are scenes of triumphal processions extolling the virtues of the sitters. Federico is drawn by two stallions while seated figures hold symbols of the four Cardinal virtues, including the scales and sword of justice. Behind him stands an angel who crowns him with a ducal coronet which was bestowed upon him by the Pope in 1474, in the same year that Edward IV made him a Knight of the Garter.

The Rout of San Romano

1454/57

Paolo Uccello

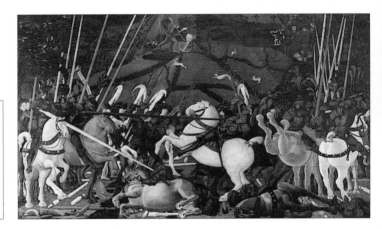

This picture is one of three that tell the story of how Niccolò Tolentino routed the forces of a Sienese mercenary, Bernardino della Carda, at the battle of San Romano in 1432. The Florentine victory over Carda was particularly poignant because he had previously fought on the behalf of Florence. Such was the adulation for Tolentino that Castagno was commissioned to paint a commemorative fresco of him in the Duomo. The first in the series, now in the National Gallery, London, illustrates Tolentino's first assault with vastly inferior forces. This is the second episode in which Carda is unseated and the third, now in the Musée du Louvre, Paris, shows the eleventh hour arrival of Micheletto da Cotignola to secure the Florentine victory.

From an inventory taken at the Palazzo Medici in 1492 we know that all three pictures were in a room used by Lorenzo the Magnificent towards the end of his life; there are curved additions to the top corners which, once removed, allowed this picture to fit within the vaulting of Lorenzo's room. Seen at over seven feet from the ground and perhaps at a tilt, the searing orthogonals of lances would make more sense. Uccello (*c.* 1396–1475) was fantastically interested in perspective and the compositional avenues opened by the use of such devices. Though a little confused and implausible, the lances and bodies which recede into space create a tangible perspective in which the warring factions fight. He has thus been able to depict the chaotic nature of battle in a painting where few precedents for such a narrative existed.

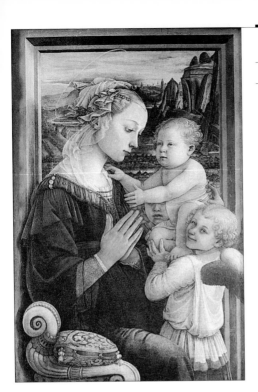

Lorenzo the Magnificent paid Filippo Lippi (*c.* 1406–69) a great compliment by erecting a monument to him when the sixty-three-year old artist died at Spoleto. Filippo's style of painting was clear and accurate with well drawn figures which have weighty form. In character, his subjects have a direct appeal for most spectators because of their sensitive inter-relationships and their evident charm. Filippo came from a family of butchers near Santa Maria del Carmine but after his father's death he entered the local monastery aged about fifteen, hence the Fra (brother) prefix to his name. Masaccio and Masolino were painting the Brancacci Chapel in the church at the time, and it must have been a great influence on the young Filippo. By the 1430s Filippo was living at the Palazzo Medici under the patronage of Cosimo il Vecchio and the direction of Piero the Gouty. It was for the latter's wife, Lucrezia Tornabuoni, that he painted this picture as well as the *Adoration of the Child*, also in this room. For all the spiritual sensitivity of his pictures, Fra Filippo Lippi had an appetite for life unbecoming to a monk. The sitter here was probably Lucrezia Buti, a nun by whom he had several children. At one time Cosimo locked Filippo into his studio because his work was so frequently interrupted by the demands of the his prodigious libido. His son, Filippino Lippi, also became an artist and trained at the workshop of Botticelli who was at one time greatly influenced by Filippo.

✪ The Birth of Venus

After 1482

Sandro Botticelli

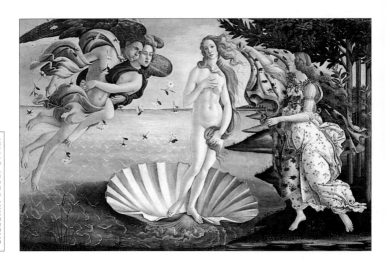

In order to secure his place as king of the gods, Saturn cut off the testicles of his father Uranus and threw them into the sea. From the foam was born Venus, goddess of love, who later married Vulcan, the divine blacksmith who made the armour for Mars, the thunderbolts for Zeus and the sharp heads for Cupid's arrows. From this disturbing tale Botticelli has drawn a serene image with no hint of violence. Venus is blown ashore by the sea breezes towards an attendant who is ready to restore her modesty. Botticelli (c. 1445–1510) has not painted with the same analytical accuracy and perspective of his contemporaries Piero della Francesca or Ghirlandaio. Venus floating towards the shore resembles a spirit upon her improbable shell; she is both an object of lust and omnipotent grace. Botticelli's ethereal interpretation of the subject links him with Neoplatonists like Marsilio Ficino and Poliziano who, in the broadest sense, took a spiritual rather than a factual view of philosophy. Such ideas were common currency at the Medici household in which Botticelli lived from early in the 1470s. His success coincided with a boom in private patronage in Florence. Peace and a relaxation of the sumptuary laws encouraged the wealthy citizens of Florence to begin to decorate their own palaces as never before with new secular subjects and portraits. This picture was painted for Lorenzo Pierfrancesco de' Medici and it was recorded at the Medici Villa of Castello by Vasari fifty years later.

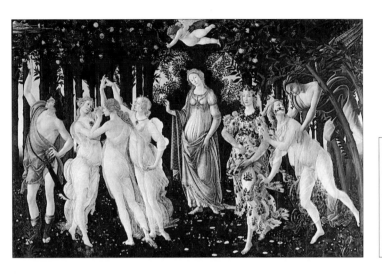

It is curious to think that until 1815 this picture was not on public display and that Botticelli (*c*. 1445–1510) remained largely unknown. Following a detailed study by Herbert Horne, whose palace is described elsewhere in this guide (page 59), Botticelli's reputation was established and this picture became one of the most famous in the world. Vasari interpreted it as the *Primavera*, or Spring, yet at no time has the precise meaning been clear. Zephyrus, the winter wind, is blowing Chloris into the picture who in turn transforms into Flora, a goddess of Spring. At the top Cupid blindly fires an arrow towards the Three Graces: Chastity, Charity and Voluptuousness. Beyond them, Mercury, using his caduceus, guides a cloud out of the garden, perhaps referring to the reportedly cloudless garden of Hesperides. It was in this garden that Paris gave the golden apple as a prize for unsurpassed beauty to Venus. The central figure may be Venus, though uncharacteristically for her she is wearing too many clothes and she appears to be pregnant. As such this picture speaks of new seasons, fertility, chance, qualities of grace and choice, yet without any apparent story or meaning. It is known that Lorenzo Pierfrancesco de' Medici, cousin of Lorenzo the Magnificent, commissioned the painting for his Florentine palace. Perhaps it was intended as a discussion piece for after dinner musing upon the nature of love. With this picture Botticelli stepped into a new realm as an artist because he was creating pictures which had the enduring sophistication of poetry, unlike his predecessors who as artists had simply narrated stories.

Adoration of the Magi

1472–75

Sandro Botticelli

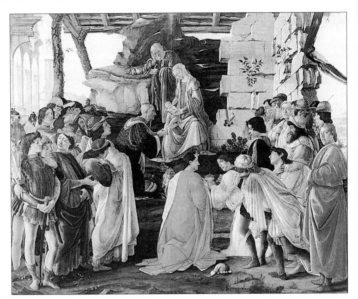

Gasparre della Lama, who commissioned this picture, used his fortune amassed as a money dealer to acquire status within Florentine society. His success was due to contacts with the Medici who are complimented throughout this picture: Cosimo il Vecchio is the oldest Magus, and his sons Piero the Gouty and Giovanni are the other two Magi. From the next generation, Lorenzo the Magnificent is on the near left holding a sword and his brother Giuliano wearing a dark suit appears towards the middle right. Bearing in mind the decorum previously observed by Gentile da Fabriano (page 40) and Benozzo Gozzoli (page 72) in other depictions of the same subject, it seems the height of arrogance that the Medici should be so ennobled. Originally set on the west wall of Santa Maria Novella, this was a very public picture, symptomatic of widespread self confidence in Florence that was shortly to end with the arrival of Savonarola. More than any other artist Botticelli (c. 1445–1510), who depicts himself with a haughty stare on the far right, was deeply changed by the alarming predictions of doom bellowed from the pulpit early in the 1490s by the monk. Every week this Dominican from Ferrara publicly chastised members of the congregation for their excesses, exhorting them to burn their possessions and follow a more simple life devoted to God. Botticelli's later paintings increasingly concentrated on moral tales like the *Calumny of Apelles*, in which a beautiful girl, led by envy, attended by vanity and dragging innocence behind her, pays court to a foolish king with donkey's ears. Way behind her stands hooded regret looking towards naked truth. Such was the end of Botticelli's own life. Once the darling of a glittering court he died in 1510, a frail and frightened man.

C. 1450

Rogier van der Weyden

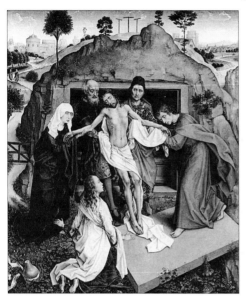

Rogier van der Weyden (1400–64) was the major artist in Flanders in the fifteenth century. For several centuries, however, his work remained unidentified and even today it is impossible to reconstruct large parts of his career. In 1450 he went to Rome for Holy Year and came back via Florence. This is one of two pictures from his stay, the other being a *sacra conversazione* of a Madonna with four saints. Though there is no evidence of who commissioned these pictures, this Entombment was once in the Medici collection and the Madonna is accompanied by Saints Cosmas and Damian, both strongly associated with the Medici.

While in Florence, Van der Weyden is said to have been impressed by Gentile da Fabriano and this picture shows some traits of Fra Angelico; the inward facing Magdalene and the tomb slab creating a sense of recession, for example. Perhaps more significant is the impact on Florence which this picture would have made. The attention to fine detail and luminescence of colour seem to have had an influence upon Piero della Francesca, while the intensity of emotion can have hardly been missed by others. Far in the background set against the sky are the three crosses of Calvary, and either side of Christ are Joseph with a beard and Nicodemus in a rich brocade tunic. Traditionally this figure has been thought to be a self-portrait of the artist.

The Portinari Triptych

c. 1475

Hugo van der Goes

Tommaso Portinari was the representative of the Medici bank in Bruges when he commissioned the Flemish artist Hugo van der Goes (d.1582) to paint this large triptych for his family chapel at Sant' Egidio, which is now part of the Santa Maria Nuova hospital near the Duomo. On the right-hand panel his wife Maria Baroncelli kneels with her daughter Margarita and behind them stand their patron saints Mary Magdalene and Margaret. To the left are Tommaso Portinari with his sons Antonio and Pigello together with St. Thomas and St. Anthony. From this left panel there is a clear indication of date because Pigello was born in 1474 and has evidently been squeezed into the composition. He would not have needed an accompanying saint because Pigello was a family name which has no saint to match. The subsequent Portinari children, Maria, Guido and Dianora are not included, suggesting a date for the picture of *c.* 1475. The right-hand panel incorporates baffling details including a ferocious dragon under the feet of St. Margaret, and one of the entourage of the approaching Magi asking a labourer for directions. The three shepherds of different ages who adore the infant Christ are characterized as ordinary working men, implying, as is meant by the story, that all mankind is included in the kingdom of heaven. Looking elsewhere in this room, one can perhaps imagine the impact of Hugo van der Goes' picture on Florence. Filippino Lippi and Ghirlandaio derived a greater sense of detail and emotional intensity from this masterpiece.

The Baptism of Christ

1470

Andrea del
Verrocchio and
Leonardo da
Vinci

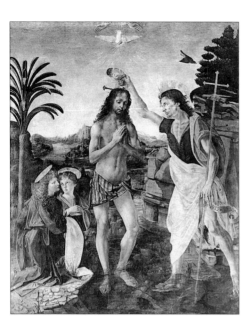

The convent of San Salvi, a little to the east of Florence, commissioned this picture from the workshop of Andrea del Verrocchio (1435–88) around 1470. At the time Leonardo da Vinci (1452–1519) was an assistant to Verrocchio and this picture is often cited as an illustration of his precocious talent. The angel to the far left and some of the landscape are attributed to him and it is clear that Leonardo's figure has a more graceful pose and his features are modelled with greater subtlety than Verrocchio's. The imbalance within the composition created by John the Baptist and Christ is adjusted by the inclusion of a palm tree signifying eternal life. Above, the hands of God send down the Holy Spirit, while a bird of prey swoops over the heads of both Christ and John prefiguring their untimely death. The two principal figures are based on a composition for a statue of Doubting Thomas which Verrocchio had been working on since 1465, and which was to be erected in the niche of the magistrates of the Mercanzia at Orsanmichele. Verrocchio was trained in the workshop of Donatello and like his master he completed many works for the Medici, particularly as a sculptor. He displayed a great interest in muscle groupings and tendons which he emphasized at the expense of the type of charm seen in figures in paintings by Botticelli or Filippo Lippi.

The Annunciation

1470S

Leonardo da Vinci

Leonardo's versatile mind led him to explore the mechanics of flight, anatomy and the circulation of the blood, and to devise huge canal systems, and strange fighting machines which look like tanks. His belief throughout was simply that reason should at all times be applied to observation. It is because this picture does not exhibit the obvious invention normally associated with him that some historians have thought it to be by Ghirlandaio. There is however an economy of composition and narrative detail here which suggests that this is an early work by Leonardo (1452–1519) painted while he was still in Verrocchio's workshop shortly after his arrival in Florence in 1469.

Unlike in other depictions of the Annunciation there is a conspicuous absence of iconographic detail. There is no olive branch for peace nor dove representing the holy spirit. Leonardo seems to assume that the spectator will guess from the juxtaposition of girl and angel that this must be the Annunciation and that the psychological drama of the story is more important than props. He has thus chosen the moment at which Mary looks up from her book, fingers still turning the pages, with an expression of graceful surprise. The buildings behind Mary indicate her worldliness as much as the trees behind Gabriel remind us of God's natural world. The foreground is given weight by the smart sepulchral urn which seems to be a quote from a Roman antique, of which drawings could easily have been circulating Florence at the time. In the distance the far off port rewards close scrutiny while displaying Leonardo's aptitude for aerial perspective.

Don Garcia de'Medici

c. 1545

Agnolo Bronzino

The Tribuna contains a number of portraits by Bronzino (1503–72) of the Medici family bearing expressions of courtly restraint, but this picture, which is probably Don Garcia as an infant, seems far more joyful and spontaneous. He was one of eight children born to Eleonora of Toledo, first wife of Cosimo I, herself portrayed nearby in a fine brocade dress with another son, Giovanni. Tragically, Eleonora and her two sons died within three days of each other suffering from malaria while en route to Pisa in 1562. Bronzino specialized in staid yet sensitive portraits which exhibit supreme virtuosity of technique. The other pictures in the Tribuna originally included the *Venus of Urbino* by Titian, now in room 28, and *The Consequences of War*, currently in the Pitti Palace.

The Tribuna

This later addition to the Uffizi was commissioned by Francesco I in 1585, and it became the jewel box of Medici patronage. A picture by Zoffany in the Queen's collection in London painted after 1772 shows it peopled by Grand Tourists examining prized pictures, curious geological specimens and inspiring statues. Most revered amongst these was the *Medici Venus*, a Roman copy of a fourth-century BC figure by Praxiteles. Arthur Young in 1789 noted 'You may view it till the unsteady eye doubts the truth of its own sensation: the cold marble seems to acquire the warmth of nature, and promise to yield to the impression of one's hand'. Close by the *Scythian*, second-century BC, sharpens the blade with which to flay Marsyas who was condemned for challenging Apollo to a singing competition. Also note the *Wrestlers* from the same century.

Adam and Eve

1528

Lucas Cranach
the Elder

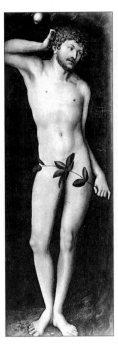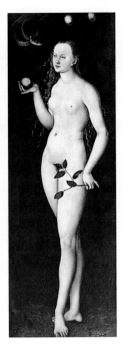

More than almost any other artist, Lucas Cranach the Elder (1472–1553) summons a real sense of temptation from his naked Eve. Proponents of deportment would be glad to see that he has tucked one leg behind the other in order to emphasize the curve of her Eve's hip, while others might notice her nipple silhouetted against her auburn hair. Eve has already bitten into the apple and offers it, with the look of one who need not flirt, to an uncomplicated Adam. Neither Adam nor Eve are the sort of ideal nude that Leonardo or Dürer sought when formulating canons of proportion and geometric eurhythmy. Instead, Cranach adheres to the northern Gothic prototype of a pear-shaped elegant woman and a gangly man. In the later 1520s Cranach seemed to specialize in these erotic nudes, depicting Venus several times and always with some prop; sometimes a floppy hat for example, thus rendering her enduringly 'chic'. Like Dürer, he was a painter, engraver and etcher of great standing and influence in the sixteenth century. He was court painter from 1505 to 1547 to the Electors of Saxony at Wittenberg and a famous portraitist. Amongst his regular sitters was Martin Luther, who nailed his doctrinal disputation, the Ninety-five Theses to the door of All Saints' Church Wittenberg in October 1517. Cranach's portrait of Luther and his wife, Catherine Bore, can be seen in this room. Cranach also printed illustrations for Protestant propaganda and signed his work with a familiar winged serpent and monogram derived from his coat of arms.

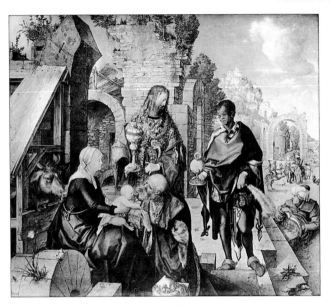

Albrecht Dürer (1471–1528) was the greatest Renaissance artist of Northern Europe and represented a new breed of international artist. During his career he travelled to Italy, the Netherlands and Aix-en-Provence in France, which allowed him to remain abreast of both artistic and intellectual developments. He was an admirer of Erasmus and Calvin and became court painter to the Holy Roman Emperors, Maximilian I in 1512, and later the omnipotent Charles V. Such was his curiosity for the novel that he once travelled to the Netherlands to track down a beached whale. While in the Zeeland, he contracted malaria and died aged fifty-seven. Evidence of his broad influences can be seen in this picture of the *Adoration of the Magi* where the perspective scheme and the excited horses in the background seem to be derived from Leonardo's depiction of the same subject of 1481 exhibited in room fifteen of the Uffizi. Thus the figures, which have a hint of Bellini and Venetian colour about them, are pushed forward in the composition. It is interesting to recollect other adoration scenes, also in this gallery, by Gentile da Fabriano (page 40), Van der Goes (page 48) and Leonardo, and reflect how direct and uncluttered is Dürer's depiction of the subject. He had originally been apprenticed to his father, a goldsmith, before moving to the much larger workshops of Michael Wolgemut where he learned wood and copperplate engraving. His fame spread later through his prints, which were also highly influential on Pontormo, Lotto and Andrea del Sarto.

Venus of Urbino

1538

Titian (Tiziano Vecellio)

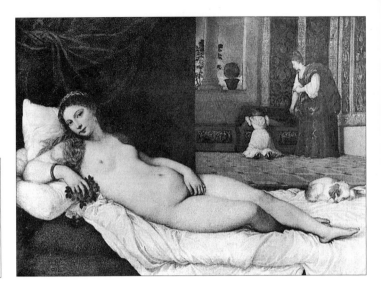

On seeing this picture in 1869, Mark Twain wrote: '…and there, against the wall, without obstructing rag or leaf, you may look upon the foulest, the vilest, the obscenest picture the world possesses… It isn't that she is naked and stretched out on a bed; no, it is the attitude of one of her arms and hand. …I saw young men gaze long and absorbedly at her; I saw aged, infirm men hang upon her charms with a pathetic interest.' He continues to appeal for freedom of the pen by pointing out the inconsistency of a world which would censor any accurate literary depiction of this picture, or for that matter 'any other moving spectacle', and yet permits the world to be seduced by Titian's *Venus*.

Even though the pose upon a bed is based on an earlier picture by Giorgione, Titian (*c.* 1490–1576) has utterly altered the sentiment of the subject with one inviting stare and a slightly more open pose which silhouettes her left breast against the shadow of her arm. It is, however, an assumption that this is Venus for there is no symbolic dove or Cupid by which to identify her. Additionally, Guidobaldo della Rovere, who commissioned the picture, fails to give any hint of its title in his correspondence on the subject. This painting comes from the middle part of Titian's career at a time when pathos was giving way to an emotional reserve in his figures, and line as a means of defining form was being replaced by subtle changes of colour and tone.

The Doni Tondo

1505

Michelangelo

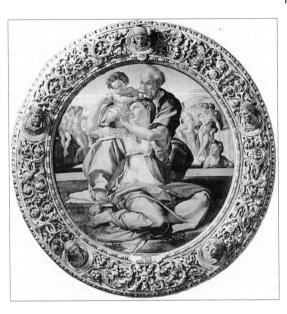

GALLERIA DEGLI UFFIZI

Michelangelo's bright and happy painting of the Holy Family was commissioned to celebrate the marriage of Agnolo Doni and Maddalena Strozzi. The Strozzi family were an important family of bankers who were great patrons of Santa Trinità (page 122) and who had a magnificent palace (page 85). Finished around 1505 this is a rare example of a painting on panel by Michelangelo (1475–1564) and it is the only surviving picture by him in Florence. It is a startling image with large imposing figures pushed to the foreground as Mary's skilfully painted elbow continues into the spectator's space. Her pose – highly reminiscent of so many of the Sistine ceiling figures – is full of movement as she twists and turns. The asymmetrical, bold grouping of Mary, Joseph and Jesus is similar to the compositions of Leonardo, representing a development in style that prefigures Mannerism. This clear direct form of representation is supported by Michelangelo's bright and seemingly discordant colours, the brittle power of which has recently been revealed by the restoration of the Sistine ceiling. Behind Mary, John the Baptist looks on from the middle ground while five unidentified nudes close the composition further back. Michelangelo had recently returned from Rome when he painted this picture. He was in his late twenties and his career was just taking off. By this stage he had completed his famous *Pietà*, now in St. Peter's, and *David*. This picture is often used to illustrate that the notion he was more of a sculptor than a painter.

Madonna with the Long Neck

1534–40

Parmigianino
(Francesco
Mazzola)

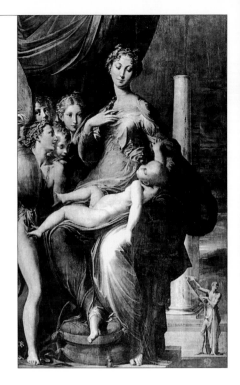

In addition to a peculiar long neck, this Madonna has a strange torso and very long legs upon which she unsteadily balances the infant Christ. He is bald and is probably about two years old. To the left, five unidentified figures attend Mary, one of them holding a large, unexplained amphora. To the right stands a single Doric column; close inspection reveals that it was originally intended as one of a row of columns. Nearby, someone who appears to be a prophet of doom reads from a scroll. The meaning of these additional symbols is not clear, though the elongation of figures may be explained by the prevailing fascination among artists and patrons for a notion of supreme grace or *grazia* . Both Mary's hand and the inclination of her head have a studied elegance which is not dissimilar to the formalized and idiosyncratic beauty of classical ballet positions. Parmigianino (1503–40) experimented with the distortion of form when he painted his own portrait from a convex mirror before moving to Rome. During the sack of that city in 1527, German mercenaries broke into his studio only to be so stunned by his work that they left it unharmed. By 1530 he was back in Parma where he became steadily more morose, developing an obsession with alchemy and spirituality. It was during this period that he painted the *Madonna with the Long Neck*, though it was never finished or delivered to the patrons, the Servite Nuns at Parma. The combination of technical brilliance, bizarre symbolism and self-conscious sophistication that we see here are typical of the Mannerist style.

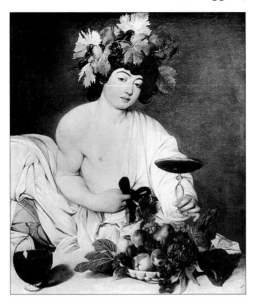

GALLERIA DEGLI UFFIZI

The subject of gossip and at least one feature film, Caravaggio (1573–1610) was notorious for his reckless private life and ceaselessly provocative as a painter. He was regularly in trouble with the police in Rome, so much so that in 1606 he fled the city supposedly having killed a man over a disputed point in a game of tennis. As a painter he skilfully struck a chord of high drama in his narratives; room forty-three in which this painting hangs contains a severed and bloody head of Medusa, depicted on a curved surface as if reflected by Perseus's shield. Another painting shows the screaming frightened fury of Isaac as Abraham tries to sacrifice him. *Bacchus* is the mythological god of wine, and curiously Caravaggio has not chosen to present him as a heroic figure from Mount Olympus, but as a youth from the streets of Rome. With candid realism Caravaggio's model sits before us with a pale torso, but reddened hands and face which alone have seen the sun. His fingernails are dirty and he has the leery look of someone who will shortly be very drunk as he engages the viewer by offering a glass of wine with an unsteady hand. In the foreground, beautifully painted rotting fruit adds to the atmosphere of decadence appropriate to Bacchus. Caravaggio came from the north of Italy, arriving in Rome in 1589. His short painting career was hugely influential, particularly his use of strong light and shade to create drama and his realistic and frequently shocking depiction of stories.

Address
Piazza de'Mozzi, Firenze
50125

Map reference

Opening times
Daily 9–2. Sun 8–1.
Closed Wed.

Entrance fee
L 5,000.

Stefano Bardini gave his eclectic museum to the city in 1923. It is an extraordinary collection which covers many areas of the decorative arts. Downstairs there are good examples of medieval sculpture including various misericords and a bust of *John the Baptist* by Andrea Sansovino. There are also interesting fifteenth- and sixteenth-century architectural fragments and crisp, sharp capitals which have been preserved from car fumes. From the fifteenth century in room nine there is a fine chimney breast by Desiderio da Settignano. On the way upstairs wonderful Turkish rugs are interspersed with some seventeenth-century paintings. Beneath beautifully restored ceilings is a small collection of armour and a number of pictures of the Madonna and Child, one of which is a copy after Bronzino. Upstairs there is a particularly striking *Flaying of Marsyas* by Luca Giordano. There is also a collection of small fifteenth-century bronzes and maiolica. Look out for a wonderful example of German sixteenth-century painted glass of *Christ Washing the Feet of the Disciples*. Possibly the best known picture in this museum is in room eighteen; it is by Antonio Pollaiuolo and shows *St. Michael and the Dragon*. In the same room there is some more fifteenth- and sixteenth-century German glass depicting the Crucifixion and a beautiful *Virgin Annunciate* made of terracotta. Finally, in room twenty there are some choir stalls by a follower of Donatello. The visitor walking around the museum will realize that the palace has been remodelled to accommodate the larger exhibits, particularly the door frames. No attempt is made to put objects into their historical context, but a great variety of artefacts are displayed with enormous care.

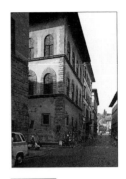

In 1916 Herbert Percy Horne (1864–1916), an English architect, writer and antiquarian, left the Palazzo degli Alberti to the city of Florence. Here there are artefacts relating to many aspects of fifteenth- and sixteenth-century life which are not covered by other museums and galleries. Off the small but nicely proportioned courtyard is a fine collection of bronze medallions and reliefs. Such items were highly prized during the Renaissance because they mimic Roman coinage, the study of which became an erudite pursuit in the 1460s. Among those displayed are portraits of Lorenzo and Piero de' Medici set in profile, as if on a coin. The two upper floors contain furniture, ceramics and fine paintings including pictures by Giotto, a wonderfully colourful *Madonna, Child and Two Angels* by Giovanni di ser Giovanni and Fra Filippo Lippi, and sculptures by Giambologna and Bernini. In the the middle of the principal room on the second floor there is a fascinating octagonal picture of about 1480 painted on both the front and back. On one side symbols from the Albizzi and the Soderini families commemorate a marriage, while on the reverse there is a gory *Last Judgment* showing the damned and the saved. It is called a *Desco da Parto* and was given to women in childbirth to hold and contemplate as if to remind them that the forthcoming child had a choice in life over which they might have some influence. Herbert Horne had a wide circle of friends including Aubrey Beardsley, James Abbott McNeill Whistler, W.B. Yeats, Max Beerbohm and Roger Fry, whom he helped to set up the *Burlington Magazine*. Most influential of all his associates was Bernard Berenson, with whom he formed the collection of paintings at the Metropolitan Art Museum of Art in New York.

Address
Via de' Benci, Firenze 50122.

Map reference

Opening times
Daily 9–1. Closed Sun.

Entrance fee
L6,000

The Holy Family

C. 1520

Domenico Beccafumi

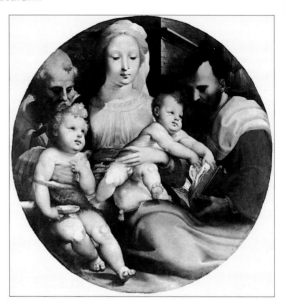

In the third room on the first floor there is a fine painting by Domenico Beccafumi (*c.* 1486–1551) of *The Holy Family*. This is a relatively rare circular painting and immediately invites comparison with Michelangelo's *Doni Tondo* in the Uffizi (page 55) or Raphael's *Madonna della Seggiola* (page 79)in the Palazzo Pitti. The Madonna holds Christ on her lap, with the unidentified donor to the right and Joseph on the left holding St. John the Baptist.

Beccafumi is an interesting artist because his career overlaps those of Michelangelo, Raphael and Leonardo, all of whom one can trace in this picture. The gentle change from shadow to highlight, known as *sfumato*, is derived from Leonardo, as is the asymmetrical composition. The bright and slightly sharp colours are reminiscent of Michelangelo's *Doni Tondo* or the Sistine Ceiling, while from Raphael comes a sweetness and emotional charm. Beccafumi was Sienese, but was in Rome between 1510 and 1512 at a most exciting time when the Sistine Chapel and Raphael's Vatican *stanze* were in progress. The hallmarks of Beccafumi's style are bright colours and sharp lighting effects. Most of his work is found in Siena where he is generally considered to have been the best painter of the sixteenth century. This picture, probably painted in the 1520s, would have been for private use and the flamboyance of the surrounding frame suggests that it was intended for a rich patron. The frame-maker was Giovanni Barilli, who also carved the wooden frame for Michelangelo's *Doni Tondo*.

It is here that marble for the Cathedral was stored and here that Michelangelo carved the great *David* which is now in the Accademia (page 32). Beyond the entrance hall there are two smaller rooms which are dedicated to Brunelleschi's work on the Duomo. A larger wooden model and a small cutaway model give a fascinating insight into the construction of the dome. In the second room some of the lifting gear developed by Brunelleschi is on display together with some of the brick moulds. Brunelleschi – whose death mask is on show – is buried under the Duomo in the foundations of the old church of Santa Reparata where the inscription describes him as an engineer and compares his achievements with the heights attained by Daedalus.

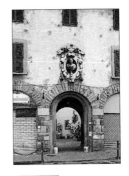

In the main hall on the ground floor there are a number of statues removed from the old Cathedral facade when it was dismantled. Amongst these are a *St. Luke* by Nanni di Banco and a *St. John the Evangelist* by Donatello. All of them have peculiar proportions because it was intended that they should be seen from far below. By the arch leading out from the hall there is a facsimile of a drawing made in 1587 which shows the extent of Arnolfo di Cambio's facade which had only reached the first storey at that time. Also on the ground floor are several models for the proposed sixteenth-century facade of the Cathedral, some illuminated psalters and a number of gory relics, including the little finger of John the Baptist. Passing Michelangelo's *Pietà* on the stairs (page 62), you come to the main hall on the first floor containing the two choir stalls, or *Cantorie* (page 63), for the Cathedral and the famous *Magdalene* by Donatello (page 63). Also on this floor are the original panels from the Campanile by Andrea Pisano and some of the bronze panels removed from Ghiberti's East Doors of the Baptistery.

Address
Piazza del Duomo, 9
Firenze 50129

Map reference

Opening times
Daily during summer
9–7:30.
Daily during winter 9–6:30.
Closed Sun.
Ticket sales stop half an
hour before closing.

Entrance fee
L 6,000.

Pietà

Before 1555

Michelangelo
Buonarroti

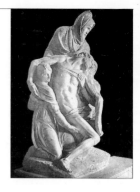

'That Love divine
Which opened to embrace us
His arms upon the cross.'

The intensity of these, Michelangelo's thoughts about his death, and his frustration at feeling inadequate to the task of creating the right image for his own tomb no doubt lead him to lash out at this composition, breaking off the leg and the lower part of Christ's left arm. Fortunately, his assistants held him back from causing further damage as he muttered that the marble was too hard and it would not obey him. Tiberio Calcagni restored the arm before finishing the Magdalene. Vasari tells us that Michelangelo (1475–1564) portrayed himself as Nicodemus at the top of the group. The sculpture was moved to the museum in 1981.

Mary Magdalene

After 1453

Donatello
(Donato di Betto
Bardi)

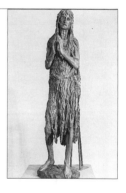

The tangled hair, emaciated body and sunken eyes are those of one close to death through deprivation, a shocking and pitiful image. Here the Magdalene is the antithesis of the vain women whom St. Antonine described as 'dishonest in mind and body'; her devotion to poverty and repentance has taken her to the threshold of death. Wooden sculptures, carved in poplar, were sometimes used in the fifteenth century for the depiction of those devoted to poverty because the use of a less expensive material was appropriate. After the flood of 1966 when the Arno reached her knees, the Magdalene was cleaned to reveal that Donatello (1386-1466) had originally painted her and that her hair was once gilded. This sculpture dates from shortly after Donatello's return from Padua in 1453.

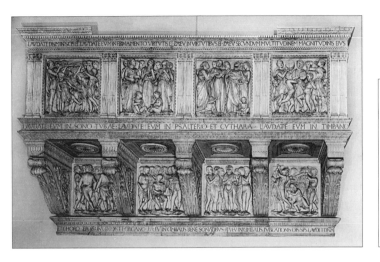

Although this balcony by Luca della Robbia (1399/1400–82) has traditionally been called a *cantoria*, or choir gallery, this is in fact an eighteenth-century title. Its original function was certainly a gallery if not, as some documents suggest, an organ loft set sixteen metres from the ground above the Sacristy door of the Cathedral. It was dismantled in 1688 to be replaced by a larger wooden choir as part of the marriage ceremony of Cosimo III's son, Ferdinando. Later it was reassembled in the Bargello and most of it is original except for the top cornice. Reading from left to right under each panel, the narrative follows the words of Psalm 150 starting from verse three: LAVDATE EVM IN SONO TVBAE (Praise him in the sounds of the trumpet) LAVDATE EVM IN PSALTERIO (Praise him in psaltery) ET CYTHARA (and citherns, or guitars) LAVDATE EVM IN TIMPANO (Praise him with drums) ET CHORO PAEV IN CORDIS (and choral dances) ET ORGANO (and organs) PAEV IN CIMBALIS BENE SONANTIBVS (Praise him upon well-tuned cymbals) IN CIMBALIS IVBILATIONS (Praise him upon jubilant cymbals). Della Robbia has squeezed up some text and slightly altered other parts in order that the panels coincide, but overall he has retained the jubilant nature of the psalm. Della Robbia's style must have been much influenced by his visit to Rome where he would have seen many relief sculptures not unlike the sarcophagus in the courtyard of this museum. Also in this room it is worth noting the other gallery by Donatello, and the sixteen prophets around the walls taken from the Campanile.

Address
Via Stibbert, 26
50134 Firenze
 468049

Map reference
⑪

How to get there
No 4 bus from the railway
station.

Opening times
Daily 9-12.45. Closed on
Thur.
Sun 9–12:30.

Entrance fee
Adults L5000; L3000 for
under 18s or over 60s.

Tours
Compulsory tours by groups
on the hour every hour.

Towards the outskirts of Florence on a gently rising hill is the Stibbert Museum and gardens. For those with the time and perhaps children, this villa is well worth visiting. Frederick Stibbert was a somewhat bluff Scottish tycoon and scholar who enjoyed a good knock around fight. His father was a Lieutenant Colonel in the Coldstream guards and his mother Giulia was Italian. Stibbert (1838–1906) was awarded a silver medal for valour for his part in the battle of Condino (1866), while fighting with Garibaldi's scouts in the Italian Wars of Unification.

The museum has some 50,000 objects, the chief part of which is a splendid collection of armour of all ages and from all around the world. This nineteenth-century building with grand faded halls is lined with regiments of dismembered arms clad in armour, mannequin horses complete with riders and countless other combatants. There are no modern display cases and artefacts are labelled very much as Stibbert left them. The overall feel is of gloomy medieval pastiche, a place where Eroll Flynn would feel quite at home. The staircase is lined with leather wallpaper and the upstairs galleries creep with reliquaries containing startling fragments of long dead saints. There are collections of musical instruments, some rooms given over to the display of malachite and others to ivories. This is a museum in which to discover a baffling range of tapestries, wooden sculptures and religious paintings from the Renaissance and other periods. The house stretches through a ballroom, galleries and halls to a total of sixty-four rooms, half of which are opened on alternate weeks. Outside in the gardens there are terracotta copies of Classical statues, a lemon house, a little temple and a romantic lake.

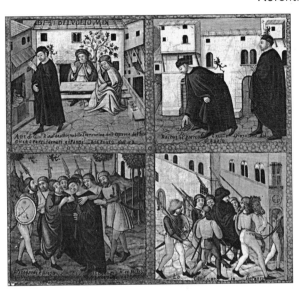

This anonymous painting is extraordinary for two reasons. First it reads as cartoon strip, and secondly it relates a moralizing story about the sad demise of Antonio Rinaldeschi. It starts in the top left-hand corner where Antonio, wearing black, leaves a table where he has been playing dice with two men. By their expression it seems that the game has not ended happily and Antonio's ill-humour is being exercised by the small devil dancing on his shoulder. Walking home he comes across a heap of horse muck which he picks up and carefully moulds into a ball. Still goaded by his dancing devil, he throws his missile at a fresco on the facade of a nearby church. Seized by remorse, he almost succeeds in committing suicide by using his knife, when he is stopped by an armed guard who has come outside the city to arrest him. In the meantime two angels have arrived to chase away the devils as Antonio is led back to Florence to be imprisoned at the Bargello.

In picture seven he is tried by eight judges and condemned. He takes confession and is led away by hooded members of the Compagnia dei Neri, a charitable lay brotherhood which cared for the condemned. As he leaves he is praying and looking at a hand board held by a hooded attendant. The board would have had some edifying picture such as the Crucifixion or the Resurrection and he would be shown this even when hanging. In the ninth picture, as Antonio hangs at seven o'clock in the evening from the window of the Bargello, two angels beat down the two devils while lifting Antonio's soul up to heaven. Four of the panels are illustrated above.

OGNISSANTI
Begun 1256

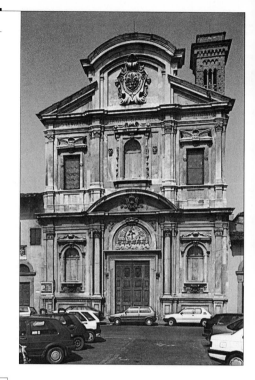

Address
Piazza Ognissanti, Firenze
50123
℡ (1) 52 17 70

Map reference
⑫

Opening times
Daily 7–12 and 4–6.
Refectory: Mon, Tue, Sat
only 9:00–12.

Entrance fee
None

The Umiliati from Lombardy were part of the Benedictine Order and established their convent here in 1256. They greatly influenced life in Florence by bringing with them many of the skills of wool processing which in time came to form the backbone of the Florentine economy. In 1561 Duke Cosimo I forcibly replaced the Umiliati with Franciscans and demolished the old monks' choir in order that the lay congregation could see the sacraments. At the time of the demolition two significant frescoes were moved into the nave. Between the third and the fourth altar on the right is a fresco from 1480 of *St. Augustine* by Botticelli, which was commissioned by the Vespucci family. Another member of that family, Amerigo Vespucci the navigator, lent his name to the Americas. Directly opposite St. Augustine is the other fresco that was moved from the choir; also dating from 1480 it is by Ghirlandaio and shows *St. Jerome*. In the left transept is the habit worn by St. Francis at the instant of his mysterious stigmata in September 1224. In the right transept is the tomb of Botticelli.

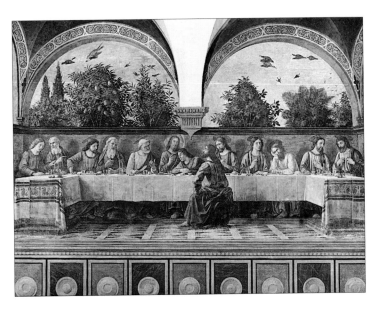

The Refectory at Ognissanti houses a large fresco running along the entire length of one wall, depicting *The Last Supper* by Domenico Ghirlandaio (1449–94). The date given towards the left-hand side is 1480. St. John the Evangelist is in the centre of the composition slumbering between Christ and Judas. Ghirlandaio has positioned the figures to inform the narrative so that Judas is depicted on our side of the table without a halo. Though we cannot see that Judas has just taken up the bread, we know this is the moment at which his betrayal is revealed because Peter, always ready to arms, has drawn his knife while glaring menacingly at Judas. In the background a bird of prey takes a duck, symbolizing the premature death of Jesus, while a dove of peace and a peacock for longevity sit on opposite window sills.

Ghirlandaio, son of a Golden Garland Master, hence his nickname, is often remembered as the man who had Michelangelo as an apprentice. The Ghirlandaio workshop was possibly the largest in Florence around 1480, employing Domenico's brother Davide and many assistants. They specialized in large church commissions, generally in fresco. Their attention to accurate detail rather than drama and emotion made them popular with the establishment of the day and more recently with Ruskin. Elsewhere in the hall the *sinopie*, or underdrawings for this picture, have been ingeniously revealed and are on display. Additionally there is a rare example of a pulpit from which the Bible was read to the monks as they ate in silence.

Ospedale degli Innocenti

Built 1419–27

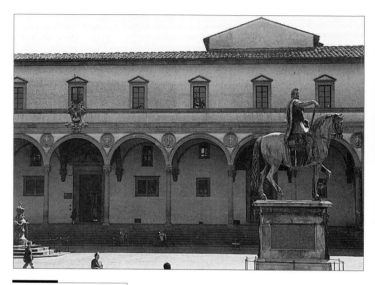

Address

Piazza SS Annunziata 12,
50122 Firenze.

✆ 2477952

Map reference

⑬

Opening times

Gallery: Daily 8:30–2. Sun
8:30–1. Closed Wed.

Entrance fee

L. 3000.

Built by Brunelleschi (1377–1446) between 1419 and 1427, the Innocenti is a fine symbol of the idea of civic responsibility in Republican Florence. This hospital is named after the children massacred by Herod and still operates as an orphanage. Since 1294 the Silk Guild, the Arte della Seta, had been responsible for foundlings in the city and following a large donation from Francesco Datini (1335–1410), a rich merchant and an orphan himself, they bought the site from the Albizzi and commissioned Brunelleschi to provide a building. The colonnade facade, of which the nine middle bays are original, is held up as among the first great architectural designs of the Renaissance, with its symmetrical proportions and uncomplicated decoration. The only decoration is some blue roundels with babies in swaddling by Andrea della Robbia on the facade, and inside the cloister for males the emblem of the Silk Guild. Upstairs there is a small picture gallery containing an *Adoration of the Magi* by Ghirlandaio, a Piero di Cosimo and a Botticelli.

Orsanmichele is among the most important buildings in the city because it was the church for the guilds. The present building dates from *c.* 1324 and originally it had an open loggia on the ground floor and offices and storage above. In 1380 Simon Talenti was commissioned to fill in the large arches with elaborate tracery windows, forming an odd church with two naves and strange juxtapositions of masonry. Every guild was represented here and from the 1330s there were plans to adorn each exterior bay with a statue appropriate to each guild. Today this forms a fine sculpture collection with work by Ghiberti, Donatello and Giambologna, although some figures have been removed for cleaning and others replaced by copies – the original St. George by Donatello, for example, is in the Bargello. The richer guilds tended to commission figures in bronze from more established sculptors. A good example is the bankers' guild statue in bronze of the tax collector, St. Matthew, by Ghiberti. The interior is covered with frescoes which also relate to the guilds. The splendid main altarpiece of the *Virgin and Child* (1347) by Bernardo Daddi is set into a lavish tabernacle.

Address
Via dei Calzaioli, Firenze 50122.
 (1) 52 17 70

Map reference
⑭

Opening times
Daily 9–12:30.

69

PALAZZO DAVANZATI
(MUSEO DELLA CASA FIORENTINA ANTICA)

Built mid–14th century

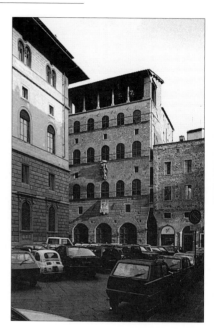

Address
Via Porta Rossa 9, Firenze
50123.
✆ 23885
Map reference
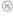

Opening times
Daily 9–2.
Closed Mon.

Entrance fee
L4,000.

The palace was originally constructed for the Davizzi family in the mid-fourteenth century and later owned by the Davanzati. It was restored by Elia Volpi in the nineteenth century and it was acquired by the state with its collection in 1951. Neither the courtyard nor the facade have the strict Renaissance symmetry of the Strozzi and Medici palaces. However, the building does provide a fascinating insight into the life of a medieval merchant family. The loggia at the top of the facade is an addition and was used for exercise and drying cloths. The ground floor hall was for storage space and a dealing room. Passing a protective *St. Christopher* on the stairs, the visitor enters the upper rooms, arranged in apartments for different generations of the family or clan. Windows, now filled with glass, were once of waxed linen and the recent invention of chimneys solved the problem of potentially smoke-filled rooms.

The Palazzo Medici was begun in 1445 by Cosimo de' Medici and was the first Renaissance palace in Florence. It now houses the offices for the local government, but one can still go inside to the second courtyard and buy a ticket to view the Medici Chapel upstairs decorated by Benozzo Gozzoli. The palace was originally designed by Michelozzo to be ten bays long but it was extended in the same style by the Riccardi family in the seventeenth century. Inside the courtyard there are elaborate Roman-style Corinthian capitals and antique medallion reliefs, collected in Rome by Lorenzo the Magnificent and set into the wall. Unlike in pre-Renaissance palaces, the ground floor was not let to shops. Instead, Cosimo il Vecchio made the corner bay closest to the Cathedral into an open loggia in which the public could meet to 'pass the time of day' protected from the hot sunshine or driving rain. This sense of largesse lay at the heart of Cosimo's political thinking, but sadly the loggia was filled in during the sixteenth century.

Address
Palazzo Medici-Riccardi, Via Cavour, Firenze 50129.

Map reference

Opening times
Daily 9–1 and 3–6.
Sun 9–1.
Closed Wed.

Entrance fee
L6,000.

✪ The Procession of the Magi

1459–60

Benozzo Gozzoli

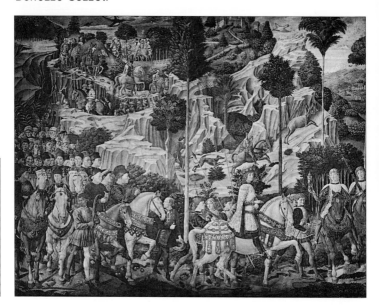

When Martin v gave permission to Cosimo de' Medici to decorate his own private chapel it was a favour almost unheard of in fifteenth-century Florence. A little later, in 1459, Cosimo's son Piero commissioned Benozzo Gozzoli (1420–97) to paint this rich and sumptuous room. With a king on each wall, the Magi process around the chapel towards the small altarpiece, originally by Fra Filippo Lippi, which shows the Madonna adoring her Child. There are countless contemporary portraits among the faces of the large group on the right-hand wall. Most interesting is the depiction of Cosimo il Vecchio who, ever cautious of popular criticism of his personal flamboyance, rides a brown donkey and wears a plain blue tunic. Riding the white horse is Piero de' Medici who is recognizable by the green and pink livery worn by his groom walking before his horse. From deep within the picture the procession winds through a landscape alive with hunting and other courtly pursuits. The attention to detail and the discrepancies of scale are features of the International Gothic, or Court style, which was quite at odds with the clarity and realism of compositions by contemporaries like Masaccio and Donatello. In this respect, Benozzo Gozzoli, a pupil of Fra Angelico, painted an old-fashioned picture and perhaps this explains why what appears to us a stunning series of paintings was never followed up by Gozzoli or others.

Remodelled c. 1530

The Pitti Palace houses three great collections. Most frequently visited is the Palatine Gallery, made up of the seventeenth-century state rooms in which an extensive collection of paintings including works by Raphael, Titian and Rubens is displayed. Running behind the principal rooms are smaller private apartments with more fine pictures by artists such as Filippo Lippi, Caravaggio, and the portraitist Marone. Most recently the nineteenth-century royal apartments have been opened, which are notable for their glittering interiors. On the top floor the Galleria d'Arte Moderna exhibits modern paintings in the broadest sense of the words from the eighteenth century up to 1910. There are several huge history paintings and an extensive collection of the nineteenth-century Florentine Impressionists known as the Macchiaioli. The last museum is the Museo degli Argenti, the entrance of which is in the left-hand corner of the courtyard, opposite the stairway for the Palatine Gallery. This is a quite overwhelming collection of gems, curiosities and jewellery with sumptuous decorative items collected from the time of Lorenzo the Magnificent until the last of the Medici. Amazing ivory sculptures follow ostrich eggs set in gold mounts and beautifully carved lumps of rock crystal. This long museum demands time set aside for its full enjoyment.

The Palace itself was built for Luca Pitti in the fifteenth century in a similar vein to the Palazzo Medici (page 71). It was later transformed by Eleonora of Toledo, who used her dowry to buy a palace so that she no longer had to tolerate the out-of-fashion apartments at the Palazzo Vecchio (page 86). Under her instruction, Ammannati extended the original seven bay building to almost its current length and completely remodelled the courtyard.

Address

Piazza Pitti, Via Gucciardini, Firenze 50125.
✆ Galleria Palatina: 213440.
✆ Galleria d'Arte Moderna: 287096.
✆ Museo degli Argenti: 294279.

Map reference

Opening times

Weekdays 9–2.
Sun 9–1.
Closed Mon.

Entrance fee

Galleria Palatina:
 L 8,000
Galleria Arte Moderna:
L 4,000
Museo degli Argenti:
L 6,000.

The Ceilings of the Galleria Palatina

After 1641

Pietro da Cortona

Painted by Pietro da Cortona (1596–1669) after 1641, the ceilings of rooms one to five in the Palatine Gallery follow the planetary gods Venus, Apollo, Mars, Jupiter and Saturn. These are the state rooms down which any visitor would progress as far as his or her status would allow and each ceiling decoration refers in some way to those who used the room. On the ceiling of the Sala di Venere used by commoners, a young adolescent boy is pulled away from the enticing arms of Venus and taken towards the guardian Hercules. Such a story of restraint was considered appropriate for the public. The Sala di Apollo, used by professionals, is topped by a scene in which Apollo, god of the Muses, instructs a young man of university age in the art of astrology. The magnificent ceiling in the Sala di Marte celebrates the physical maturity of the the same young man as he is taught the arts of war by Mars. With a ducal coronet at the centre of this ceiling, we realize that we are witnessing the divine education of a prince and we can assume the this is either a call to arms or a veiled threat to disconsolate courtiers who would tangle with this excellently trained prince. He is crowned in the next chamber, the main reception room, by Jupiter, the king of the gods. Thereafter he is ushered up to Saturn, god of the underworld, in the withdrawing room. The contemporary significance of this scheme is that by a divine education, princes may become kings with divine rights. In England, meanwhile, civil war was breaking out over this very principle.

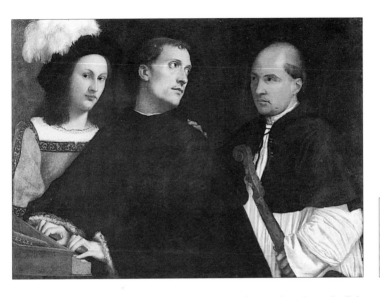

This picture attributed to Titian (*c.* 1485–1576) is utterly enigmatic. It is described above as *The Concert* but it is also known as the *Three Ages of Man* and it is often debated whether Giorgione, Titian's teacher, might have had a hand in its painting. What is certain is that it does come from the early sixteenth century and that in 1664 it was acquired for the Medici by Cardinal Leopoldo de' Medici. It is also known from a print by Lasinio that it has been cut down by some twenty centimetres. This does not seem to affect the iconographical content of the picture, which remains unclear. It is true that these three men are of quite different ages and backgrounds; a Dominican monk in a black and white habit is contrasted with a somewhat effete young man wearing expensive-looking brocade. It may be, of course, that the instruments played and the costumes worn are in some way a metaphor for three ages. The same is true of a picture in the National Gallery, London, where Titian paints a young man above a fox, a middle-aged man above a lion and an old man with a wolf. In early sixteenth-century Venice there was a fashion for obtuse pictures and Giorgione certainly specialized in them. Without exception they were small works for private consumption and required a degree of erudition to make sense of them. Not unlike the *Primavera* by Botticelli (page 45), they were perhaps intended to stimulate idle theorizing after dinner.

Portrait of Pietro Arentino

c. 1545

Titian
(Tiziano Vecellio)

Titian (c. 1545–1576) painted the writer Pietro Aretino several times, and this picture probably dates from the c. 1545 at a time when his style of painting had become more fluid. Aretino first sat for Titian in 1527 just after he had arrived in Venice, escaping from the Sack of Rome and the displeasure of the authorities who had attributed some particularly obscene sonnets to him. By comparison, Venice was a tolerant place and Aretino, who was an adept self-publicist, made sure he had his portrait painted by the young and highly successful artist. With this started a great friendship that would last decades. Aretino was a professional letter writer of sorts and on many occasions ghost wrote letters for Titian. The power of his own pen was such that through him Titian was introduced to Charles v of Spain, who was also Holy Roman Emperor, in 1532. Aretino's influence was derived from a style of public letter which he had developed whereby he corresponded with many of the most important figures in Europe. Full of feigned praise and misrepresentation, Aretino's letters lampooned and ridiculed the greatest names in Europe while he hid behind his relative insignificance and the absence of libel laws. A thoroughly dangerous and amusing man, most people loved him until he wrote about them. He died at home while throwing himself backwards having heard a good joke. An epitaph read 'Here lies Pietro Aretino, a Tuscan poet; Evil he spoke of all, except God; when questioned why he said, "Him I didn't know".'

In this double portrait of Charles I and his wife Henrietta Maria we see Van Dyck (1599–1641) as a rare example of a sensitive court portrait painter who is able to depict state figures as individuals rather than wrapped in the trappings of their office. This is a style of portraiture that he learned during a four-year stay in Italy. Though not especially successful in Rome, Van Dyck prospered in Genoa, where the boom in shipping and trade brought wealth to a new generation of merchants anxious to establish their palaces. On leaving Italy he spent some time trying to break into court circles in his homeland, Flanders, before moving to another aspiring nation, Britain. His vivacious style caught the eye of Charles I who, despite his political ineptitude, was an inspired patron of the arts. Soon Van Dyck supplanted the stilted North European style of Mytens and Johnson to replace it with a more intimate, flowing form of portraiture gleaned from his Genoese experience.

This often copied double portrait was painted during his stay in England from 1632 to 1641. Less forthright than his master Rubens, Van Dyck nonetheless built himself a distinguished career as a diplomatic painter and was rewarded by his services to the state by the knighthood bestowed upon him by Charles I. The marriage of Charles to Henrietta Maria came out of a swing of alliance from Spain to France following Charles's abortive efforts to marry the Infanta of Spain. From this rather inauspicious beginning Henrietta went on to have seven children with Charles, who remained a devoted husband until his untimely execution in 1649.

c. 1638

Sir Peter Paul Rubens

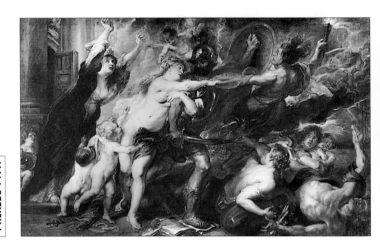

In 1638 Rubens (1577–1640) sent this painting to his friend and country-man Sustermans, who at the time was court artist to the Medici, with a letter noting all the details and declaring that the picture could be read like a poem. At the centre of the picture Venus, goddess of love, tries without much success to restrain warring Mars who marches off to the right. He is pulled by a powerful wild-eyed figure who brandishes a spitting torch to represent jealousy and envy. Along the bottom of the picture a woman holding sheet music and clutching a broken lute, struggles for space next to a shattered Corinthian capital. Near her, Mars has disrespectfully planted his foot on a book which is on top of a crumpled drawing of the Three Graces; this represents the wholesale destruction of the arts in times of war. Towards the left, Cupid anxiously clutches at the Venus while his normally trusty arrows lie disarranged on the ground. By these is the discarded winged staff of the messenger god Mercury, whose skills of eloquence made him the deity most associated with diplomacy. Above Europa, dressed in black, bewails what has come to pass while behind her the doors of the temple of Janus, which are chained shut in times of peace, have crept open. Finally, hiding amongst the skirts of Europe, a well-fed cherub clings to an Orb, a symbol of monarchy. Here the normally glorious associations of war and kingship have been reversed suggesting, perhaps, that the Thirty Years War raging elsewhere in Europe was too dangerous a pursuit for any state, especially a small grand dukedom like Tuscany.

Portrait of a Lady

c. 1514–15

Raphael
(Raffaello Sanzio)

Painted in Rome at a time when Raphael (1483–1520) was working at the court of the Medici Pope, Leo X, this portrait is sometimes called *La Velata* (the veiled lady) or *La Fornarina* after the daughter of a baker in Trastevere. Of all the portraits from the sixteenth century this must be among the most beautifully sensitive and serene. Not a line seems hurried or omitted and the woman's sleeve displays astonishing technical virtuosity. She was the model for the Sistine Madonna and is thought to have been Raphael's mistress. Raphael died not long after painting this in 1520 at the age of thirty-seven having been overwhelmed with work since *c.* 1510. He had assembled a large workshop of assistants who helped spread his influence far and wide.

Madonna della Seggiola

c. 1515

Raphael
(Raffaello Sanzio)

Placing the Madonna and Child in a roundel seems to have been a very Florentine tradition but this picture is generally assumed to stem from Raphael's time in Rome around 1515. There are similarities between this and Michelangelo's *Doni Tondo* in the Uffizi (page 55) which also has monumental figures and an asymmetrical composition. This, however, is where the similarities end: where Michelangelo conveys sharp form and angst, Raphael (1483–1520) creates grace in paint with soft lines and beautiful colours. The influence of Raphael spread with this picture, copied so many times by subsequent generations right up to the mid-nineteenth century when the Pre-Raphaelites in England proposed a return to forms of art that existed before Raphael.

Agnolo Doni and Maddalena Strozzi

1506

Raphael (Raffello Sanzio)

 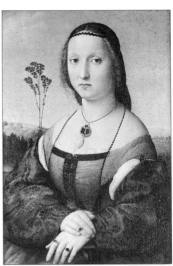

These portraits celebrate the marriage of Agnolo Doni to Maddalena Strozzi. He was a young and prosperous weaver and she came from arguably the richest family in Florence. Some indication of her wealth is given by her bold necklace and her gem rings. It is quite probable that she could have worn more finery but, at the time, sumptuary laws forbade the wearing of any more than two rings on each hand. Much like the portraits of Leonardo, notably the *Mona Lisa*, Raphael has brought both sitters right to the front of the picture plane; Agnolo Doni's arm rests on a balustrade close enough to touch. Yet there is a psychological distance between the sitter and the viewer which in the case of Doni promotes an impression of watchfulness and intelligence.

There is a certain fresh naivety about these pictures in that Raphael does not employ a microscopic attention to anatomical detail which can so easily rob the sitter of mystique. The crisp light and bright colours of these portraits reflects Raphael's Umbrian heritage; he had been trained at the court of Duke of Urbino under Perugino. In 1504 armed with a letter of introduction, Raphael moved to Florence where he came into contact with Fra Bartolommeo, Leonardo and Michelangelo, who was working on *David* at the time. Michelangelo had also recently finished his only known oil painting, the *Doni Tondo*, now in the Uffizi (page 55), which was painted in 1503 to commemorate this marriage.

Bernardo Gaffuri and Jacques Bilivert

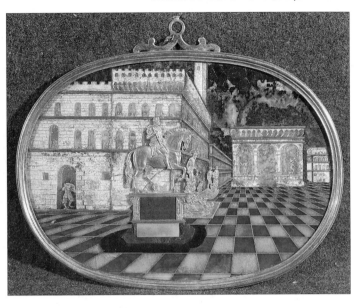

No photograph can do justice to this cameo, which is in the Museo degli Argenti, because its complexity and extraordinary sense of perspective are only apparent at first hand. The effect is achieved not by laying different types of glass next to one another but by layering them to create a type of relief. As a result the grey glass areas of the Loggia and the Palazzo Signoria have a real sense of depth. More obvious techniques of creating perspective are the receding and converging lines of the pavement and the cornicing of applied gold which stands clear of the the glass. The sky is made of lapis lazuli which has its own natural white blemishes to represent clouds.

All this was executed in 1599 by Bernardo Gaffuri, a Milanese craftsman who had moved to Florence to take advantage of the flamboyant patronage of the Medici Dukes, particularly Francesco I and Ferdinando I, in this type of gem work. The second craftsman involved was Jacques Bilivert (d. 1603), a Dutch goldsmith who had been invited to Florence in 1573 by Francesco to be director of his gallery. On this cameo he cast all the monuments of the piazza in gold and inlaid tiny figures leaning out of the windows of the Palazzo Signoria. Originally designed for a German made cabinet which stood in the Tribuna of the Uffizi, it was moved to the Florentine museum of Lo Specola in the eighteenth century and then to the Pitti. In the meantime the cabinet has been lost.

Ecco Homo

1889

Antonio Ciseri

Recently brought to the Galleria d'Arte Moderna on loan from Rome, this enormous picture is normally described as a history painting. This genre was largely restricted to battle scenes during the Renaissance and intended for propaganda purposes. From late in the eighteenth century, however, the taste for large histories to cover the walls of both public institutions and private homes became more pronounced. History paintings became the currency of the establishment, and those attending a state academy of art either in Florence, Paris or London would be directed towards this sort of work. In general, history paintings display high levels of technical skill and *Ecce Homo* by Ciseri (1821–1899) is no exception. We see Christ presented before the people as Pontius Pilate leans over the balcony to judge the mob's response. The attention to detail, particularly in Pilate's hand, is compelling and one can almost feel the heat of the bright sunlight. The only drawback to these types of pictures is, ironically, their proximity to pastiche, occasionally making them seem like Hollywood sets. Ciseri was instructed at the Accademia in Florence by Giuseppe Bezzuoli, whose large Rubensesque picture of the *Entry of Charles VIII into Florence 1494*, is also on show here. Ciseri went on to become a professor at the Accademia in 1852, where he taught many of the Florentine Impressionists known as the Macchiaioli.

Giovanni Fattori (1825–1908) was a leading member of a group known as the Macchiaioli and he is very well represented in the Galleria d'Arte Moderna. The term Macchiaioli derives from *macchie*, or spots of colour, and the group is generally described as Italy's, and particularly Tuscany's, answer to the Impressionists. Like the Impressionists in France, the Macchiaioli preferred to paint outdoors, concentrating on light and colour while avoiding historical subject matter in favour of nature or social commentary. Fattori is most closely associated with Lega and Signorini having been jointly influenced by Corot and Courbet. He visited Paris a year after the Impressionist exhibition of 1875 but by that stage he was already fifty, and an independent and wilful character who had fought in the War of Independence between 1848and 1849. Many of his pictures illustrate battles and there are hundreds of small panel sketches of soldiers at rest. He seems to have had a great understanding of nature and his depiction of horses is wonderful.

Normally in Fattori's art man controls nature, yet around 1880 he began to paint a number of pictures where the roles are reversed. In *Lo Staffato* (*staffa* means stirrup) a dead man is dragged by the horse who has thrown him. Another painting depicting a herdsman being dragged by an enraged oxen follows the same theme. Fattori's morbid interests coincided with the availability of Japanese prints in Europe, which may explain the block-like appearance of this composition.

PALAZZO RUCELLAI

Built c. 1451

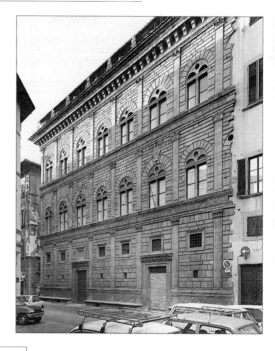

Address
Via della Vigna Nuova,
Firenze 50123.

Map reference

Opening times
Not generally open to the
public.

Symmetry, logic and proportion in the design of buildings were ideas written about by the first century BC Roman critic Vitruvius and interpreted here by Leon Battista Alberti (*c.* 1404–72) and Bernardo Rossellino (1404–64). Thus the height and spacing of the pilasters (flat columns) relate to one another, and the design seems to have been thought through from the outset. Direct quotes from antiquity include moulded cornices and the diamond-shaped incised design at street level, which is said to derive from Roman brick work. It is not true, however, that this is entirely a Roman palace because the capitals and rustication remain identifiably Tuscan, if not Florentine. This palace represents, therefore, a sophisticated assimilation of Classical ideas while still remaining nationalistic. Unfortunately, its balanced design was never finished because Giovanni Rucellai who commissioned it was unable to buy the adjoining palace to the right. The palace now houses a photographic archive whose rooms are theoretically open to the public, but the most impressive and accessible part of the building is the facade.

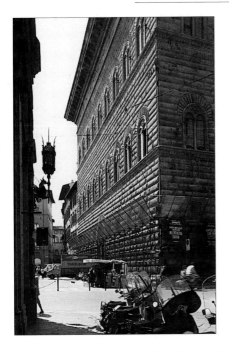

Together with the Palazzo Rucellai, Palazzo Pitti and Palazzo Medici, this is one of the great mercantile palaces of the Renaissance. It was begun in 1489 and remained under construction until 1536. As with so many fifteenth-century building projects, it is difficult to decide who was actually responsible for the design. In this case the patron Filippo Strozzi definitely had a large part to play, as did Lorenzo de' Medici, another gentleman architect. Giuliano di Sangallo (1445–1516) and Il Cronaca (1457–1508) are associated with the project and Benedetto da Maiano (1442–92) probably designed the exterior ironwork, which is superb. The lanterns, torch holders and the horse rings all carry the Strozzi emblem of three crescent moons. The palace now houses a library and a number of learned institutes and provides space for temporary exhibitions. Unfortunately, the main state rooms are not usually open to the public, but other parts of the palace can be viewed from time to time during exhibitions

Address
Via degli Strozzi, Firenze
50123

Map reference

Opening times
Part of the palace open periodically during temporary exhibitions.

Begun 1299

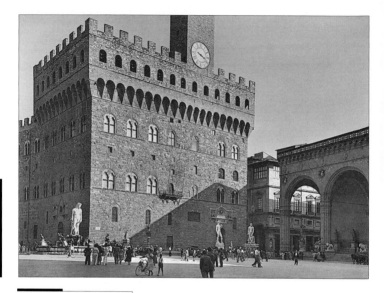

Address
Piazza Signoria, Firenze
50122.
2768465

Map reference
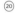

Opening times
Daily 9–17. Sun 8–1. Closed
Thur.
Ticket Office closes one
hour before closing.

Entrance fee
L 8,000.

Once known as the Palazzo del Popolo, or Palace of the People, this imposing building was started in 1299 by Arnolfo di Cambio (*c.* 1245–1302) under the direction of the triumphant Guelph party who, after years of struggle against the old feudal parties, had won the right to self determination for the merchant classes. The building remained largely unchanged until the temporary expulsion of the Medici in 1494, after which a new council chamber for five hundred (the Salone dei Cinquecento) was created. Booty from Medici palaces was brought here including Verrocchio's *Putto with a Dolphin*, a copy of which can be seen in the courtyard. In 1537, when Cosimo I came to live in the palace he redecorated many rooms to form apartments for himself and his wife Eleonora. When his son Francesco married Anne of Austria, Vasari was instructed to paint scenes from her homeland in the main courtyard lest she should become homesick.

After the expulsion of the Medici in 1494, Savonarola reformed the government by creating a voting council of five hundred which met in the Salone dei Cinquecento. The Salone was started in July 1495, and was ready for business by February the next year; it was largely designed by Il Cronaca (1457–1508). After Savonarola's death, Soderini commissioned two great pictures from Leonardo and Michelangelo celebrating republican Florentine victories over the city's favourite enemies, Pisa and Milan. They were never finished and tragically what remained of them was destroyed by Cosimo I who preferred to celebrate his own victories over Siena and Pisa. The present pictures and the ceiling are by Vasari's workshop and throughout they applaud Tuscany as a nation state and Cosimo as its leader. The podium is by Bandinelli and features Cosimo himself and two Medici Popes, Leo X and Clement VII. Elsewhere in the room is the *Victory* by Michelangelo, originally made for the tomb of Julius II, and amusing depictions of the *Labours of Hercules* by Vincenzo de'Rossi.

Off this hall is a small study used by Cosimo's son, Francesco I. He was a keen alchemist and the decorations here refer to the creation of minerals. High up at either end are portraits of Francesco's parents, Cosimo and Eleonora, by Bronzino. From this room a secret passageway leads to a treasury and onto the covered corridor leading across the Arno to the Pitti Palace.

The Apartments of Duke Cosimo I and Eleonora of Toledo

Decorations begun 1540

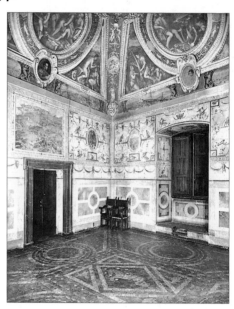

Passing through the apartments of Leo X, a staircase decorated with elaborate grotesques by Vasari leads to the separate apartments of Cosimo and his wife Eleonora. The first of Cosimo's rooms is dedicated to the Elements and the artist Bronzino started the scheme on the ceiling where Saturn castrates his father Uranus as assurance against any future rival. From the old man's testicles Venus is born and comes ashore on the wall opposite to signify water. Her husband, Vulcan, is depicted appropriately on the chimney breast making thunderbolts for Zeus and arrow-heads for Cupid. On the leading wall Ceres brings the fruits of the Earth to Saturn. Other rooms in Cosimo's apartments are dedicated to Hercules and Zeus and a series of rooms, sometimes open, exhibit works of art recovered after the last war.

In the apartments of Eleonora her private chapel is by Bronzino and dated 1540. Thereafter, a series of rooms by Vasari and his workshop refer to great virtuous women: the Sabine women, who after their rape and abduction stood between their own men and the Romans to stop senseless bloodshed; Esther, a brave Old Testament queen who dares to contradict her husband; and finally Penelope, wife of the absent Ulysses, who is a symbol of patience. One can see the difficulties sixteenth-century artists faced when making a decorative scheme within an old building by looking towards the top of the windows where the medieval decorations are quite clear. After Eleonora's apartments there are more administrative rooms of government.

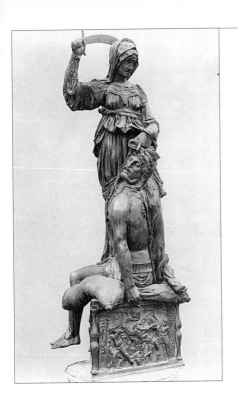

This late bronze by Donatello (1386–1466) tells the story of Judith and Holofernes from the Old Testament. Judith was a rich and beautiful widow from the Jewish city of Bethulia, who devised a scheme to release her city from the grip of Holofernes and his army. Having entered his camp under the pretence that she would give away secret information about the defences of Bethulia, she allowed Holofernes, who had been away from home for months, to think that he might seduce her. After a great dinner he had prepared for her, she took advantage of their privacy and cut off his head. Once the army of Holofernes realized they had lost their leader, they fled in disarray.

Donatello goes into graphic detail as Judith hacks at the half-severed, broken neck of Holofernes while biting her lip at the thought of her invidious task. Like the story of David, the tale of Judith was seen as a republican allegory in Florence, in that the weak but just triumph over the strong and despotic. This sculpture was first commissioned by Donatello's good friend Cosimo de' Medici in 1456, and until 1494 it stood in the second courtyard of the Medici Palace. With the resurgence of republicanism at that time it was moved outside into the Loggia dei Lanzi from which it was later ousted by Giambologna's *Rape of a Sabine* (page 91). Originally it was to be a fountain with water running from the corners of the cushion. It has recently been restored.

PIAZZA SIGNORIA
AND THE LOGGIA DEI LANZI

Piazza laid out c. 1290

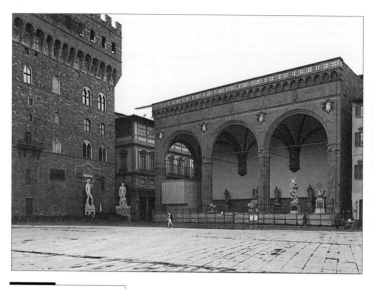

Address

Piazza Signoria, Firenze

✆ (1) 52 17 70

Map reference

㉑

When in the thirteenth century the Florentine Republic built its palace for government it did so over the top of the headquarters of the city's previous rulers within the Ghibelline faction in Florence. Recent archaeological excavation of the Piazza has revealed the foundations of the large palaces which were cleared to make a space large enough to hold the *Balia*, or public meeting, by which a new government was elected. Other events which took place here, including the execution of Savonarola, are commemorated by a porphyry plaque set into the pavement in front of the fountain. Around the square the Republic erected statues with democratic overtones such as Michelangelo's *David* (page 33) and Donatello's *Judith* (page 89). Under Cosimo I, the Piazza was transformed into a sculpture court by filling the Loggia, which had once been used for public meetings, with works by Giambologna (page 91) and Cellini (page 92). Cosimo also renamed the Loggia after his body guard of Swiss Lancers, the Lanzichenecchi.

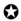
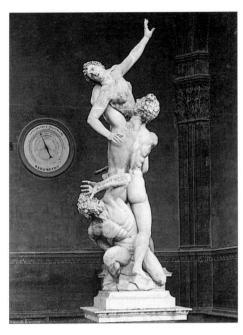

When this composition was unveiled in January 1583 it provoked much discussion, not least because there was no apparent title. Subsequently it was named after the bronze reliefs on the plinth, which are also by Giambologna (1529–1608). The idea for this statue had started four years earlier when Ottavio Farnese commissioned a small bronze of two struggling figures, a man and a woman, from the sculptor. Later, the Grand Duke Francesco I asked Giambologna to develop the composition into a monumental sculpture which could be viewed in the round for the gardens at his Villa at Pratolino. Owing to structural problems, Giambologna added a third figure which alleviates the inherent weakness around the ankles of the first male nude. When it was nearing completion the Grand Duke decided to position it in the Loggia replacing the *Judith and Holofernes* by Donatello (page 89). Today it is difficult to get the full measure of Giambologna's composition because one is not allowed to walk inside the Loggia, but there is the plaster model on display in the Accademia which enables one to appreciate the composition. Giambologna was Franco-Flemish and had studied in Rome before moving to Florence to become court sculptor to the Medici. Technically he was a skilled innovator and administratively he was an astute business man, taking on skilled assistants to whom he delegated some of his ever growing work load.

Perseus and Medusa

1553

Benvenuto Cellini

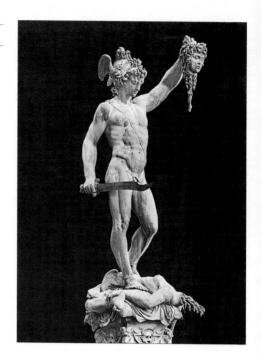

Benvenuto Cellini (1500–1571) originally trained as a goldsmith and enjoyed a celebrated career. Between 1519 and 1540 he worked in Rome, occasionally for the Medici Pope Clement VII. His most famous piece is a large saltcellar which he made for François I of France, which is now in the Kunsthistoriches Museum, Vienna. Towards the end of his life he wrote an amusing autobiography, which is still widely available in paperback.

Though signed 1553, this statue was eventually unveiled in 1554 after ten years of preparation. It was originally commissioned by the Medici for their Villa at Poggio a Caiano outside Florence. Owing to public acclaim, however, it was set in the Loggia dei Lanzi as a pendant to the *Judith and Holofernes* by Donatello (page 89). The latter, in turn, was replaced by Giambologna's *Rape of a Sabine* (page 91). The original partner to this statue was perhaps more appropriate in that both tell the story of a hero or heroine decapitating a stronger and seemingly omnipotent foe. In order to pass Medusa, sometimes called the Gorgon, Perseus had to kill her. Her power stemmed from her deadly eyes which turned others to stone at a single direct glance. Perseus cleverly polished his shield so that he could view the Gorgon unharmed while he aimed his deadly blow. Here we see him triumphantly raising the severed head of Medusa. Cunningly, he kept the head in a sack, revealing it only when he needed to use the putrid stare to turn others to stone.

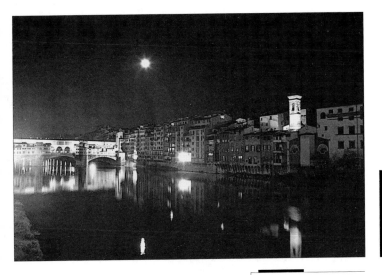

After the flood of 1333 the present bridge was built with shops on either side of the walkway so that the rents could maintain the bridge. At first these were occupied by tanners who preferred a breezy situation for their malodorous trade, which involved curing hides in horse urine for eight months. Later the bridge was taken over by butchers and eventually Ferdinand I, who so enjoyed jewellery, insisted that only goldsmiths should occupy the bridge. Benvenuto Cellini, Florence's most distinguished goldsmith, is commemorated in a bust positioned halfway across. At about the same time, Vasari added a corridor above the shops on the left-hand side so that the Medici could move from the study of Francesco I, off the Salone dei Cinquecento in the Palazzo Vecchio, to the Palazzo Pitti on the other side of the Arno without hindrance. In 1944 the bridge narrowly escaped destruction when, as the German army retreated north, Gerhard Wolf, the German Consul, persuaded others not to destroy all the bridges across the Arno but to render the Ponte Vecchio impassable by felling buildings at either end.

Address
Ponte Vecchio, Riva Arno, Firenze
✆ (1) 52 17 70

Map reference
 ㉒

Built 1339–1445

Address
Via Ventisette Aprile, 1,
Firenze 50121.

Map reference
(23)

Opening times
Daily: 9–2. Sun: 9–1.
Closed Mon.

Entrance fee
Free.

All that remains to be seen at the Benedictine convent of Sant'Apollonia is the old refectory. The convent was founded in 1339, and in 1445 the nuns were granted permission by Eugenius IV to decorate their dining hall. Andrea Castagno (*c.* 1421–57) was appointed for the task, which was finished *c.* 1450. He painted a large scheme which included *The Last Supper*, *The Crucifixion*, *The Entombment* and *The Resurrection*. In recent years this has been made into a greater monument to the work of Castagno because the original frescoes have been lifted so that the *sinopie*, or under-drawings, can be seen. This gives a rare opportunity for visitors to view the exhaustive preparation process of the fresco painter and to see the power of Castagno's drawings. Apart from this there is nothing else at Sant'Apollonia. The convent was closed in 1860 and the other buildings are part of a military barracks.

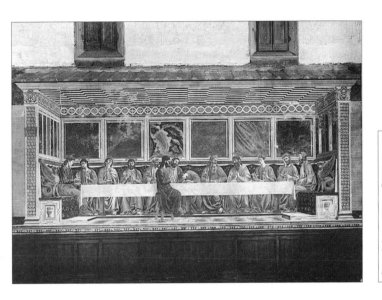

Judas is shown on one side of the table at the instant of his exposure. The bread in his hand is clearly visible by John's halo and, to the right, those apostles who can see clearly react obviously to the shocking news. Following the description in St. John's Gospel, Judas is hideously ugly with a hooked nose, gnarled ears and sunken eyes, as if consumed with the devil. The architecture is a loggia with a roof and two Florentine pilasters in the foreground. Other depictions of the Last Supper tend to link the architecture in the painting with the architecture of the room in which the picture is placed, as in Ghirlandaio's *Last Supper* at Ognissanti (page 67).

Castagno's version was finished by *c.* 1450 and it seems that he worked fast. Since fresco is the application of water-based paint onto an area of wet plaster, it is possible to count each day's work, or *giornata*, by tracing the join of one day's plaster against the next. Castagno (*c.* 1421–57) appears to have completed the work in thirty-two days, and the figures of James and Peter, almost incredibly, were painted in a single day. The whole scheme was large, including additional paintings of the *Crucifixion*, the *Entombment* and the *Resurrection* though these are now quite damaged. Recently the frescoes have been removed to show some fascinating *sinopia*, or under-drawings. It is possible that Castagno's bold style and clear perspective would have had a greater impact on his contemporaries had these paintings not been hidden behind the closed doors of this convent until 1860, when the state appropriated the institution.

SANTI APOSTOLI

Begun 10th century

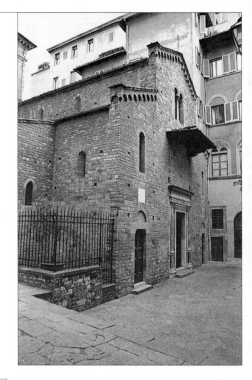

Address
Borgo SS Apostoli, Firenze 50123.
✆ (1) 52 17 70

Map reference
㉔

Opening times
Daily 8:30–12:30 and 4–6.

Such is the age of this church, first recorded in 1075, that it is sunk below the normal pavement line. It has a plain Romanesque facade save for a marble sixteenth-century marble door frame, and inside the nave is dark, quiet, dank and moving. The surrounds of the uppermost windows bear the remnants of fresco decoration which perhaps once covered the interior. The plan is based on a Roman basilica, or hall, without transepts, and with three apses at the east end. It is possible that Brunelleschi derived some inspiration from the Classical elements of this interior. During the Renaissance Santi Apostoli was patronized by the Acciaioli family, whose emblem of a lioness rampant can be seen on the facade. Donato Acciaioli (d.1333) is buried inside in a colourful tomb by Andrea della Robbia. Two flints, which originate from the Holy Sepulchre, are stored in the church. Each year on Easter morning, outside the Duomo, they are used to light the fuse of a rocket which propels a model dove down along a wire into a tower of fireworks. With luck all the fireworks ignite in an explosion of sparks: a good display augurs well for Florence's fortunes in the year ahead.

Begun 1294

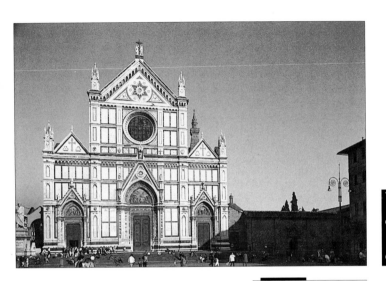

Santa Croce means Holy Cross, which is a significant name for the Franciscan Order because their founder, St. Francis, received the signs of the cross, or stigmata, while devoutly contemplating the death of Christ. The present church was started in 1294 at the same time as Santa Maria Novella, the large Dominican church (page 112). The interior was frescoed but the the paintings were sadly lost due to the Counter-Reformationary verve of Cosimo I who, following the direction of the Council of Trent, demanded the whitewashing of decorated interiors that caused distraction from the altar. Not unlike the Duomo (page 29), the facade of Santa Croce remained bare until the nineteenth century when the present pastiche polychrome marble front was attached. Santa Croce is a popular mausoleum and many great names are commemorated here, including Michelangelo and Galileo. There is also an interesting leather factory off the south transept.

Address
Piazza Santa Croce, Firenze 50122

Map reference
 25

Opening times
Daily 7:15–12:30; 3–6:30.

Opening times for the Pazzi, Bardi and Peruzzi Chapels
Daily except Wed.
Summer: 10–12:30 and 2:30–6:30.
Winter: 10–12:30; 3–5.

Entrance fee to Pazzi Chapel
L 3,000.

The Bardi and Peruzzi Chapels

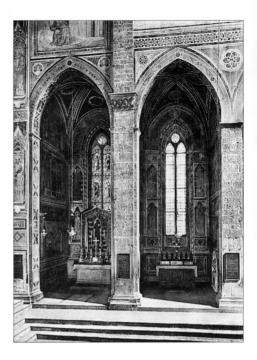

Immediately to the right of the altar are two small chapels with important fresco cycles that were painted early in the fourteenth century. They were paid for by the Bardi and Peruzzi families respectively as a public demonstration of their status within Florentine society. In decorating their chapels both families probably employed the greatest living artist of the period, Giotto (*c*. 1267–1337), though there is no conclusive evidence to prove this. In the Bardi Chapel the cycle begins at the top left with St. Francis renouncing all his goods and stripping off his garments in front of his father and the surprised Bishop of Assisi. Opposite, Francis establishes the rule of his Order and below he is tried by fire before the Sultan. Two other frescoes refer to his appearance before St. Anthony of Arles and Brother Augustine. Lastly, at the bottom left, Francis is mourned on his death bed while in a deliberate allusion to the story of Doubting Thomas, Bardi himself inserts his fingers into the wound left by the saint's stigmata.

The Peruzzi chapel next door illustrates the lives of St. John the Baptist and St. John the Evangelist. On the right wall, top to bottom, is St. John on Patmos; the raising of his housekeeper Druisiana and his ascent into heaven. On the left wall Zaccarias is told by an angel that, despite his age, he will have a son named John. In the middle John the Baptist is born and below is Herod's Feast, which led to his demise.

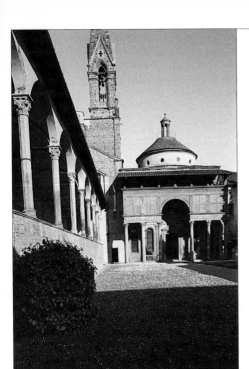

The Pazzi Chapel was built between 1442 and 1446 as a chapter house for the monks of Santa Croce. It also served as a mausoleum for the Pazzi, a wealthy Florentine banking family who paid for its design and construction by the architect Filippo Brunelleschi (1377–1446). They were later to disgrace themselves by plotting to overthrow the Medici family in 1478. When their attempt failed the decaying body of one family member who had recently been buried here was dug up, paraded through the streets and thrown into the river.

Despite this rather distasteful episode the chapel is considered by many to be Brunelleschi's masterpiece and the most perfect expression of the ideals of the Florentine Renaissance. Rectangular in plan, Brunelleschi divided the space into a cube topped by a semi-spherical dome and flanked by two shortened barrel vaults. The whitewashed interior is articulated by Corinthian pilasters carved from Brunelleschi's characteristic grey *pietra serena* stone. The effect may initially seem somewhat plain but it becomes increasingly clear to the observer that any bolder or more colourful ornamentation would seriously detract from the ordered, calm and harmonious rhythms that Brunelleschi was seeking to create. Renaissance thought placed unprecedented emphasis on man's rational nature. If man was made in the image of God, as the Bible claims, then it followed that God was perfect Reason. Church architecture, it was argued, should directly reflect His nature. This is a sober yet exalted ideal, and Brunelleschi was possibly its finest architectural exponent. Entrance to the chapel is through a door to the right of the church facade.

The Crucifixion

c. 1280

Cimabue
(Cenni di Pepi)

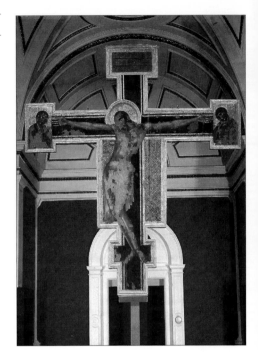

Cimabue (*c.* 1240–1302) occupies an important place in the history of Western painting. He was among the first artists to break away from the conventions of painting set by the Eastern church. Essentially this entailed placing greater stress on the realistic appearance of the body and attempting to convey emotion. Through his use of light and dark shading, Cimabue tried to capture a sense of solidity and volume. He completed important work at Assisi, where his influence can also be seen in the work of his greatest pupil, Giotto.

Cimabue's *Crucifixion,* painted in the 1280s, is now in the Museo di Santa Croce, just to the right of the Pazzi Chapel. It was badly damaged in the flood of 1966 when the waters of the Arno rose to the level of Christ's brow; the damage can clearly be seen in the photograph above which shows the painting before restoration. Although the entire work has been restored and relined, those areas where paint has flaked away have not been retouched. Even so the work, originally painted to stand in the middle of the nave of Santa Croce, has lost little of its grave dramatic power. Christ's body, shaded in a cadaverous green colour, arches elegantly on the cross and there is a symmetry whereby the hands and feet of Jesus lie on the circumference of a circle drawn using the navel as its centre. Yet this geometrically organized pose still forcefully expresses the pain and suffering of the Cross, as does the knotted grimace of the face. The bust-length figures to the left and right of Christ are the Virgin Mary and St. John the Evangelist in mourning.

The church of Santa Felicità is thought to stand on the site of the first Christian burial ground in Florence. In the area of the city that was settled in the second century by Syrian Greeks, the church became a convent for Benedictines who built a Gothic structure here in 1380. Parts of this were subsequently remodelled by Brunelleschi in the fifteenth century, and in 1565 Vasari built the Medici's private corridor that traverses the river and runs straight across the facade. In the eighteenth century the medieval building was all but torn down and rebuilt by Ferdinando Ruggieri (c. 1691–1741), except for the cloister and chapter house, which can be seen by asking the sacristan. St. Felicity was a popular saint. She was a rich widow who lived in the second century, whose seven sons were martyred before her. In the third bay on the right a fine work by the academician Antonio Ciseri illustrates a similar story of the martyrdom of seven sons, the Maccabei.

Address
Via Guicciardini, Firenze
50125.
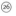 (1) 52 17 70

Map reference
㉖

Opening times
Daily 9–12:30.

The Deposition

1425

Jacopo Pontormo

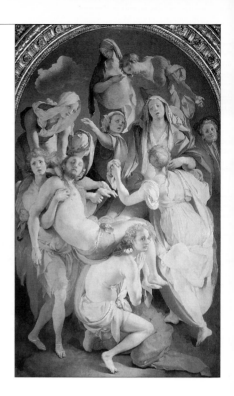

The Capponi acquired the rights to the first chapel on the right in Santa Felicità in 1425 from the Barbadori, who had previously commissioned Brunelleschi in about 1423 to fashion a Classically inspired architectural framework in grey *pietra serena*. Under the patronage of the Capponi, Jacopo Pontormo (1494–1556) was asked to paint an *Annunciation* spanning the window to the right, to set four roundels of the Evangelists into the ceiling (St. Mark is by Pontormo's pupil Bronzino) and to paint the now famous *Deposition*. Unlike in other pictures of this subject, Christ, Mary and their attendants float in a vacant landscape. Going against the late fifteenth-century pursuit of realism, Jacopo Pontormo sized figures according to their hierarchical importance and the physique of some, particularly the foremost supporter, is governed by the composition rather than anatomical reality.

With its sharp colours and swirling composition, the *Deposition* is regarded as a pinnacle of Mannerism. Meaning in a literal sense 'mannered', this is a rather ill-defined style which in its broadest sense refers to sophisticated, if not quirky pictures and architecture. This should not be taken to mean that artists like Pontormo adopted a haphazard approach. On the contrary, for this picture he has focused on the function of the chapel as a mausoleum for the Capponi family, in which the dead and the repose of the soul are considered. Every part of this picture from the swooning Madonna to Christ's limp hand and the whimpering expression common to all, invokes an overwhelming sense of grief.

San Lorenzo is thought to be the earliest church in Florence; its site was consecrated by St. Ambrose in 393. Its present appearance owes much to the continued patronage of the Medici family, who commissioned Brunelleschi (1377–1446) to rebuild the church in the 1420s. Owing to a prolonged recession Cosimo de' Medici, son of Giovanni di Bicci, was asked to underwrite the whole project in 1443. In return for such a large cash injection the Medici retained the right to put their coat of arms (six balls) on each one of the aisle vaults and Cosimo was promised the most prestigious burial spot, under the altar. From the outside the most striking blemish is the absence of a facade. One was commissioned from Michelangelo by Leo X but the designs never progressed beyond a model which can still be seen at the Casa Buonarroti. Inside, Brunelleschi has created a serene style of architecture based on regularity, logic and proportion. Also inside are two pulpits which were the last work of Donatello and a fine fresco showing *The Martyrdom of St. Lawrence* by Bronzino.

Address
Plazza San Lorenzo, Firenze 50123.
✆ (1) 52 17 70

Map reference
㉗

Opening times for the New Sacristy and Capella dei Principi
Daily 9–2 except Mon.

Opening times for the Laurentian Library
Daily 9–1. Closed Sun and Public Holidays.

Opening times for Church
Daily 8:30–12:30, 4–6.

Entrance fee
The New Sacristy and the Capella dei Principi L9,000.

The Laurentian Library

Built 1524–71

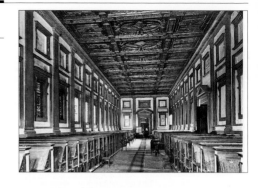

In November 1524 Clement VII, the second Medici Pope, commissioned Michelangelo (1475–1564) to build a library complex to house the manuscript collection assembled by Cosimo il Vecchio and Lorenzo the Magnificent. It was planned to have a vestibule with a staircase, a long reading room and a curious triangular rare book room, which sadly was never built. Michelangelo played havoc with many of the rules of Classical architecture while creating a moody unease within the interior which is quite unlike the calm serenity of Brunelleschi's church below. Load bearing Doric columns are supported by inadequate consoles and the heavy grey stone crowds in on the limited space. The vestibule was finished in 1571 by Vasari and Ammannati some time after Michelangelo's death, and its architectural decoration is dramatic and provocative.

The Cappella dei Principi

Begun 1605

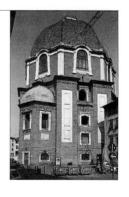

First thought of by Cosimo I, this was intended as a funerary chapel for the Medici dukes, and many of them can be seen commemorated around the walls. Based on the dimensions of the Baptistery, this large domed structure completes the Medici domination of San Lorenzo. Either side of the altar in the sacristies are buried Medici, directly in front of the altar is Cosimo il Vecchio, and directly beyond the altar is the mausoleum for the dukes of Tuscany. The main body of the building was designed by Matteo Nigetti (1560–1649) in about 1605, but work on the marble inlay and ceiling decoration continued long into the eighteenth century. The stunning decoration of marble and semi-precious stones, called *pietra dura,* was produced by the grand ducal studio set up in 1588.

Giovanni di Bicci de' Medici was well rewarded for his leading role in plans to rebuild San Lorenzo by being given the decorative rights to the Sacristy. He is buried under the central vestments table and the remains of his two grandsons, Piero and Giovanni, are enclosed in a large porphyry sarcophagus near the door. Far from being a Sacristy, this room became a shrine to the Medici as the most powerful political force in fifteenth-century Florence. In the small dome above the altar is an astrological chart showing the position of the stars on 6 July 1439, the date on which an accord was signed between the Eastern and Western churches in Florence. Cosimo de' Medici had been responsible for hosting the conference in Florence, and it was a considerable coup for the city and his family. In the small arches in the corner are four relief decorations by Luca della Robbia designed by Donatello, which describe the life of John the Evangelist. Donatello also cast the doors either side of the small domed chapel. To the right are scenes of the Apostles arguing and discussing, while on the left saints do the same. Discourse was a popular humanist pursuit in the fifteenth century, when argument and rhetoric became an art much as they had been in the ancient world in the time of Socrates or Cicero. Behind the left-hand doors is a wash basin by Verrocchio which displays various Medici symbols: the bejewelled ring, the hawk, and the motto *Semper*. The architect was Brunelleschi (1377–1446), who was also responsible for rebuilding the main body of the church.

⭐ The New Sacristy

Built 1519–34

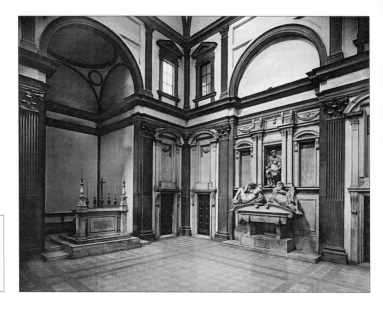

The New Sacristy, designed by Michelangelo (1475–1564) was commissioned by Clement VII while he was still a cardinal to commemorate his father Giuliano de' Medici, killed in the Pazzi rebellion, and his uncle, Lorenzo the Magnificent. They are buried within the entrance wall close to the Michelangelo's statue of the *Madonna and Child* and underneath Sts. Cosmas and Damian, who are both associated with medicine and therefore the Medici. Though this chapel was never completed, it was hailed at the time as a triumph for Michelangelo. It was originally conceived to complement Brunelleschi's Old Sacristy in ground plan and the articulation of the interior. On either side of the chapel are the famous reclining statues of *Dawn*, *Dusk*, *Night* and *Day*, which support the funerary monuments of two more lesser-known Medici: Lorenzo, Duke of Urbino and Giuliano, Duke of Nemours, both cousins of Clement VII. Michelangelo incorporated two great tabernacles which frame statues of the dukes. Both are dressed in Roman Imperial armour as befits captains of the Roman church invested as dukes on the Capitoline Hill in Rome. On the Duke of Urbino's sarcophagus Michelangelo has placed *Dawn* opposite *Dusk*, while on the Duke of Nemours' tomb female *Night* is set against male *Day*. *Night* adopts a closed pose, and is accompanied by a mask, an owl and a crescent. Her counterpart, *Dawn*, is noticeably younger and has a more open pose. The meaning of this arrangement, which originally included four river gods, has been greatly pondered. It may relate to the fact that Mass for the repose of the souls of the dead Medici was said in this chapel four times a day.

Founded in 1299, the Church of San Marco was occupied by the Vallombrosans and later the Sylvestrine monks. By the early fifteenth century the convent was in such bad repair that Eugenius IV, who had come to Florence in 1436 to consecrate the finished Cathedral and was a good friend of Cosimo de'Medici, made the site over to the Dominicans in order that they might develop a pilgrim's hospice. Between 1437 and 1452 Michelozzo (1396–1472) redesigned many of the buildings as the financial burden fell ever more heavily on the willing shoulders of Cosimo de' Medici. Vasari remodelled much of the church in the 1560s and the present facade dates from the eighteenth century. To the right of the church, a door leads to the Museo di San Marco, which is dedicated to the works of Fra Angelico (page 109). The Chapter House and Refectory have many large and fine paintings by Fra Angelico and, in the small Refectory, there is a *Last Supper* by Domenico Ghirlandaio.

Address
Piazza San Marco,
Via Cavour, Firenze 50123
✆ 23885

Map reference
㉘

Opening times for Museo di San Marco.
Daily except Mon, 9–2.
Sun 9–1.

Entrance fee
L 6,000.

✪ Decorations in the monks' cells

After 1438

Fra Angelico

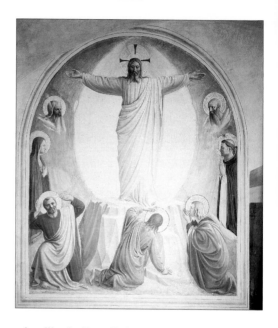

While more ancient orders like the Benedictines maintained that monks should sleep in long dormitories with many beds, the Dominicans preferred to house their monks in individual cells. The reason for the difference was that the mission of a Dominican, unlike a Benedictine, was to preach, teach and evangelize. It followed that for this external challenge monks needed a modicum of comfort, and privacy for study and essential prayer. The cells decorated by Fra Angelico (c. 1400–55) were furnished with a simple bed, a desk and a *prie-dieu* for prayer. The pictures were there to aid meditation and the decoration was chosen according to the seniority of the intended occupant. For example, cell seventeen used by a novice has a fresco depicting St. Dominic at prayer by the Cross. Most other novice cells have the same subject though they vary slightly in that there are three positions of the hands. Each pose denotes a different subject for prayer; St.Dominic himself recognized that prayer was the foundation of faith. Cells intended for older monks have less repetitive subjects and amongst the best is in cell seven depicting the *Mocking of Christ*. Dismembered hands and sticks prompt the memory of the whole event rather than evoking a progressive narrative. Cells thirty-eight and thirty-nine were for Cosimo de' Medici's personal use; they were not too far from the excellent library which he gave to the hospice as a public amenity. Further round one can see cells twelve to fourteen once occupied by the infamous Savonarola, who was made Prior in 1491. Fra Angelico himself was made Prior and has recently been beatified.

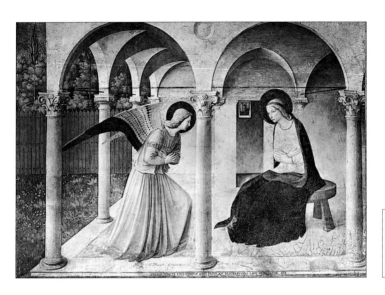

Fra Angelico (*c*. 1400–55) joined the order of St. Dominic in 1407 as a novitiate monk at the Dominican monastery at Fiesole. When the church of San Marco was expanded as a monastery in 1438 he was put to work by the Prior Antonino to decorate parts of the cloisters and the cells and to make altarpieces for many Dominican institutions around Florence and Tuscany. At the head of the stairs leading to the monks' cells one is greeted by a picture of the *Annunciation* by Fra Angelico. It is immediately striking for its clear simplicity with none of the supplementary symbols such as the dove or olive branch normally associated with this subject. An unimposing Gabriel delivers his shattering news to a biddable Mary in an uncomplicated world where grace alone reigns. Underneath the inscription warns: 'As you venerate, while passing before it, this figure of the intact Virgin, beware lest you omit to say Hail Mary.' Though the story is simply told, it would be a mistake to think that the composition is not ingenious. For example, the line of the step running back from the bottom left follows through the body of the angel. If continued it would strike the arch directly above Mary's head, setting up a strong triangular composition. The capitals, the tie beams and the window beyond Mary's head lend emphasis to the gaze from Gabriel to Mary, while the column between them reminds one of their differing physical status.

SANTA MARIA DEL CARMINE

Built 1268

Address
Piazza del Carmine, Firenze
50124

Map reference

Opening times for Church
Daily 9–12, and 4–6.

Opening times for Brancacci Chapel
Daily except Tue. 10–5. Sun 1–5.

Entrance fee to Brancacci Chapel
L 5,000.

Founded in 1250, the convent was actually built in 1268 in this rather remote southwest quarter of the medieval city. A fire almost completely ruined the church in 1771 and it was restored with rather unremarkable Baroque decoration and a huge wide nave. By complete good fortune the fire did not substantially damage the Brancacci Chapel in the south transept. The Carmelites were the third large, urban-based Evangelical order founded in the thirteenth century. Where the Franciscan mission is towards the poor and the Dominicans towards informed preaching, the Carmelites have a special emphasis on healing and medicine which is reflected in the Brancacci chapel. As a result Carmelite churches tend to be found near poor areas or barracks. This is also the monastery from which the rogue painter Fra Filippo Lippi emerged.

The Brancacci Chapel

1427–8

Masaccio
(Tommaso di ser
Giovanni di Mone)
and Masolino da
Panicale

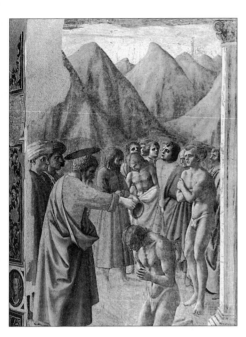

Arguably the greatest painted scheme of the early Renaissance, this chapel was jointly executed by Masaccio (1401–c. 1428) and Masolino (1383–c. 1440). It was finally completed some fifty years later by Filippino Lippi (c. 1457-1504). Recently restored, it is a curious arrangement of pictures which relate to the life of St. Peter, the Carmelite Order and contemporary events. Best known is the *Tribute Money* on the upper register of the left-hand wall, which tells the story of how the disciples were barred entry to a city until they had paid a levy. Not having any money, Jesus explains to a confused Peter that by the bank of a nearby river he will find a fish with a coin in its mouth. If Christ accepted such a tax, why not the citizens of Florence who were, at the time, making an unprecedented declaration of their income, known as the *Catastro*, for tax assessment? Directly opposite is *Peter Cures a Cripple and Raises Tabitha*, the background of which gives a good impression of the streets of fourteenth-century Florence. Since cleaning it is now easier to distinguish Masaccio's work from Masolino's, which is less stilted and portrays character types with touching humanity. One of the best examples of this is on the back wall (shown above) where St. Peter baptizes a chilly Neophyte as another hugs himself with cold in the background. Sadly Masaccio died c. 1438 while taking a break from this commission in Rome. He was only about twenty-seven. Entrance to the chapel is through a door to the right of the church facade.

Begun 1246

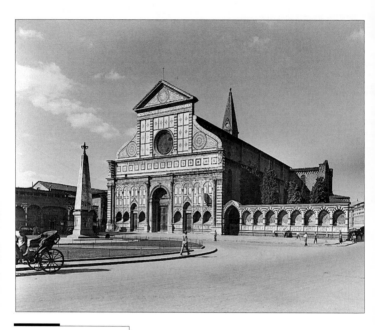

Address
Piazza Santa Maria Novella,
Firenze 50123.

Map reference
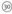

Opening times
Daily 10–12:30 and
3:30–6:30.

Santa Maria Novella is the principal Dominican church in the city. Its site was donated by the Tornaquinci family in 1221 and work began on the new church in 1246. The Dominicans were formed early in the thirteenth century by St. Dominic as an evangelical order, and the interior of Santa Maria Novella is vast enough to accommodate a large congregation with the pulpit accordingly set well down the nave. The original building scheme is reflected on the exterior by a row of tombs and a coloured marble Gothic facade to the height of the first storey. Above this is the work of Leon Battista Alberti (1404–72), who completed the facade between 1456 and 1470. Giovanni Rucellai, who commissioned him, proclaimed his achievement with an inscription dated 1470. Alberti's rational mind may be detected in the symmetry of the facade. As at Palazzo Rucellai (page 84) inset marble decoration of a billowing sail and three feathers, derived from Medici heraldry, can be seen dotted around the exterior celebrating the marriage of Giovanni's son to Bernardo to Piero the Gouty's daughter.

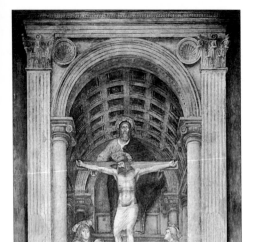

This fresco was a funerary monument for Domenico Lenzi and his wife, who kneel above a skeleton bearing the chilling inscription, ' I was what you are and what I am you will be'. Above them, St. John the Evangelist prays opposite Mary and, between the heads of Christ and God, there is a white dove symbolizing the Holy Ghost. The picture title is significant for Dominicans because Trinity Sunday is the beginning of the Dominican year and here Masaccio (1401–c. 1428) has tackled a difficult abstract concept: God presents to us his son, whom we have killed, but without retribution and as the ultimate symbol of forgiveness. With great clarity Masaccio delivers to the viewer a statement of fact: that through the death of Jesus, the Trinity is complete and a new order reigns based on the principle of forgiveness. As if to reinforce this assertion, the coincidence of the architecture and figures sets up a geometric logic within a well-defined space which is neat and rational. For example, a line drawn from Domenico Lenzi's head to Mary's, and from his wife's to St. John's, would meet in the middle of Christ's chest which, in turn, is level with the back Ionic capital. The arch springing from these capitals rounds the shoulders of God and helps to frame the Holy Ghost. A comparison with a contemporary *Adoration of the Magi* by Gentile da Fabriano (page 40) shows how innovative Masaccio was as a technical artist and thinker. There is little detail, no disparity of scale between figures and, for the first time, an inscription has been written on a painting in Roman capitals.

The Strozzi Chapel

1486–1502

Filippino Lippi

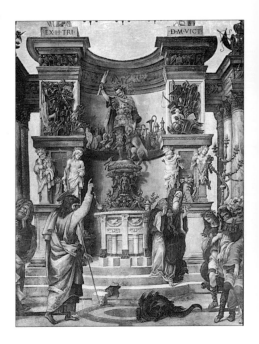

Filippino Lippi (1458–1504) trained first with his father Filippo and later with Botticelli. Like Ghirlandaio, he was a decorative painter who was well-known in his day for large schemes such as this, commissioned by affluent patrons keen to acquire impressive looking chapels. The overall theological theme here was of Salvation, but the decision to depict the life of St. Philip is surely because the patron's name was Filippo Strozzi. He had acquired the rights to this chapel when the previous owners, the Boni, went bankrupt in 1486. Like Giovanni Tornabuoni in the next chapel, Filippo wanted an expensive scheme which included stained glass windows, frescoes by Lippi and an altar which is also his tomb.

To the right of the chapel the principal painting tells how St. Philip the Apostle arrived at Hieropolis in Asia Minor to find the city in the grip of an evil spirit emanating from the temple of Mars. Philip exorcized the temple causing a foul creature to emerge. As it expired the beast delivered a hideous smell that was so dreadful that many people died, including the King's son. The high priest was so exceedingly angry that even though Philip quickly restored the boy to life, the saint could not avoid being crucified. On the left wall St. John the Evangelist revives his dead housekeeper below a picture of his own martyrdom by boiling. In both stories Lippi displays a great sense of drama and a broad range of antique references derived at first hand from Rome.

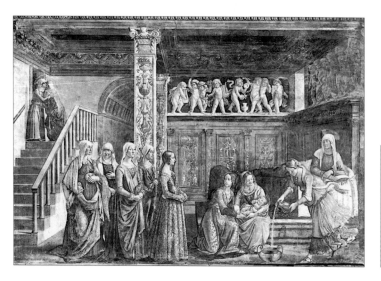

In 1486 Giovanni Tornabuoni commissioned this lavish scheme of decoration, which had become necessary after a bolt of lightening had damaged Orcagna's fourteenth-century frescoes. Ghirlandaio (1449–94) designed the stained glass and frescoes, and an entire workshop was employed to execute this vast scheme. Though in fresco, and therefore supposedly less expensive than oil painting, there are over twenty portraits which pushed the total cost of the chapel to over 1000 florins. The decorative scheme follows Orcagna's original by telling the life stories of the Virgin Mary and St. John the Baptist. At the birth of the Virgin, Anne sits up in bed as Giovanni Tornabuoni's daughter Ludovica comes to call. The whole scene is set in fifteenth-century Florence in the home of a wealthy merchant, while the 'grotesque' architectural border conforms to the very latest in sophisticated Roman design. It can also be seen on the columns and in the panelling around the room and is based on the recently rediscovered Golden House of Nero in Rome. So exciting was this discovery that Ghirlandaio sent all the members of his workshop to take drawings of the relief decoration which had survived almost 1500 years in cave-like ruins, known as *grotte* in Italian. These clear, accurate and professional frescoes sum up the air of confidence in Florence a few years before Savonarola drove the Medici from the city.

CHIOSTRO VERDE

Built 1348

Address
Piazza Santa Maria Novella,
Firenze 50123.

Map reference

Opening times
Weekdays 9–2. Sun 9–1.
Closed Fri.

Entrance fee
L4,000.
L2000 for pensioners and
under eighteens.

These cloisters, to the left of Santa Maria Novella, were constructed in 1348. In 1418 the government, realizing the need for state guest apartments, made funds available to further develop the site. Thus Cosimo de' Medici was able to offer well-appointed accommodation to the Western delegation of the Council of Ferrara in 1439 so that they might continue their vital discussions with the Eastern Orthodox Church. The reason most people visit the cloisters today is an extraordinary picture of *The Deluge* painted by Paolo Uccello in 1447. This is part of an Old Testament cycle painted in green monochrome which gives rise to the name of Chiostro Verde, or Green Cloister. The one exception to this colour scheme is Uccello's ochre-coloured picture, in which he to gives full vent to his interest in perspective. The composition is dictated by the searing perspectives created by side views of two pyramidal Arks. To the left, mayhem reigns as lightning strikes a tree and a terrified woman clings to the side of the closed Ark. Man's worst nature is revealed as two men in the foreground fight each other for survival. To the right, Noah gathers in his dove.

Andrea di Bonaiuto

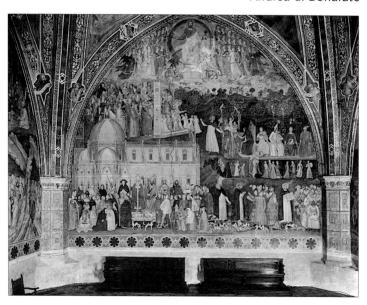

On the right wall of the Spanish Chapel leading off the Chiostro Verde, this large fresco best reveals the aspirations of the Dominican order. Theologically their views were conservative and closely allied those of the Church hierarchy, which can be seen at the bottom right of the picture where a Papal council meets. At the feet of the Pope lie some pure white dogs together with other black-and-white dogs whose coats mimic the colours of a Dominican habit. *Domini Canes*, or Hounds of God, is also a pun on the Dominican name. Further to the right, Dominicans teach and argue with non-believers while their dogs fight brown wolves. Above, Dominicans bless and help the good on their way to Heaven.

Throughout Bonaiuto's cycle, which extends over all the walls, the benefits of religious government over secular rule are stressed, reminding us that this chapel was regularly used as a Chapter House. Perhaps it was in order to illuminate the propaganda discussed there that Bonaiuto (active *c*. 1343–77) steered clear of realistic scale and perspective. Bonaiuto was also a member of the management committee responsible for the erection of the Duomo, which may explain the inclusion of the Cathedral, Dome and all, fifty years before Brunelleschi's plan. In the sixteenth century the Viceroy of Naples and father of Eleonora of Toledo used the building when he attended the official marriage of his daughter to Cosimo I. Thereafter a Spanish community remained, and this great Chapter House became known as the Spanish Chapel.

⭐ SAN MINIATO AL MONTE

Begun 1090

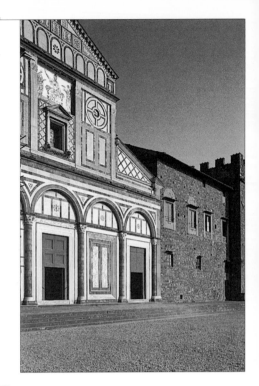

Address
Piazzale Michelangelo,
Firenze 50125.
✆ (1) 52 17 70

Map reference
③②

How to get there
Take the No 13 bus from the
Duomo or railway station to
Piazzale Michelangelo. Walk
a little further up the hill to
see the church on the left.

Opening times
Daily 7–12:30 and
3:30–6:30.

San Miniato is a little known but significant saint for the people of Florence because he was the first Christian martyr killed *c.* 250. The bold geometrically designed facade of the church can be seen clearly from below and the panoramic views from San Miniato are no less spectacular. The present church dates from the eleventh century and was paid for by Matilda of Tuscany, who was also responsible for the decoration of the Baptistery. With its coloured marble facade San Miniato is a prime example of Tuscan Romanesque architecture. The cool dark interior evokes a spiritual atmosphere which, given a well-timed visit, is greatly enhanced by Mass sung from the sunken crypt by resident monks. Worthy of note are the capitals, probably assembled from Roman ruins at Fiesole, which tend not to match their columns, and the colourful Renaissance chapel dedicated to the Portuguese Cardinal, Jacopo di Lusitania, halfway down the left aisle.

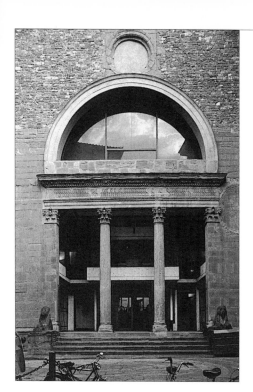

San Pancrazio was patronized by the Rucellai in the same way that the Strozzi adopted Santa Trinità. From the outside it looks rather peculiar with a portal of Roman columns, entablature and thermal window applied to a medieval facade of *c.* 1375. It is generally agreed that the scholar and architectural consultant Alberti (1404–72) played a role in this design, which draws all its architectural detail directly from Roman buildings. To the right of the facade is the Cappella di San Sepolcro, the funerary chapel for Giovanni Rucellai, open for Mass once a week on Saturday evenings. The tomb is based on the dimensions of the Holy Sepulchre in Jerusalem which Giovanni Rucellai had had measured. In most matters Giovanni Rucellai was a successful man. In 1457 he was recorded as the third richest man in Florence and he married into the immensely wealthy Strozzi family. The church was deconsecrated in 1809 and used for many years as a tobacco factory. Recently it has been imaginatively transformed into a permanent exhibition of the work of Marino Marini.

Address

Via di Spada, Firenze 50123.

© 219432

Map reference

Opening times

Daily except Tue
10–1 and 3–6.

Entrance fee

L 6,000.

1959

Marino Marini

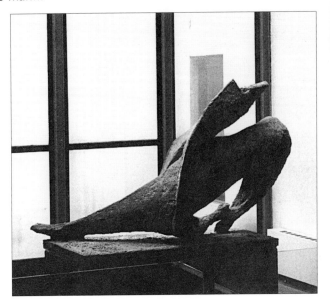

Marino Marini (1901–66) is often linked with Alexander Calder, Alberto Giacometti and Henry Moore as one of the four principal sculptors of twentieth-century Europe. None had direct contact with the others, but they cannot have failed to be aware each other's work. Marino Marini started out as a painter and as such was influenced by the neo-primitivism of Gauguin, Picasso and Matisse. He trained in Tuscany and remained strongly influenced by the Tuscan and Etruscan past, which comes through in his lifelong passion for bronze and the theme of man and horse. In following this route he was the complete antithesis of the Futurists and Dadaists, who derived inspiration from the machine age, preferring 'as a man of the Mediterranean world…to express myself freely through the medium of the human'. Marini's work is never regressive, but always positive and rigid with energy. In this gallery it is possible to follow the progression of this theme from his horses on all four legs with men on their backs, to the mayhem of his horse and riders torn in every direction but never apart. His early work on horses and Pomona, a goddess of fertility, are statements of fact and sexuality, unlike the *Miracolo*, which shows him to be a master of space and a commander of the perilous.

Santo Spirito is the principal parish church on the south side of the river and its piazza, with its small market, acts as one of the more informal forums in the city. An Augustinian church had been here since 1292, but the monks decided to remodel it in 1428 because the buoyant economy led them to believe that the parish could afford it. The architect, Filippo Brunelleschi (1377–1446), finished the designs by 1438, but construction did not begin until two years before his death. Inside the proportions of the entire building are set by a square unit or module, which can easily be seen in the floor paving which, by its multiple, governs the width of the nave, the aisle, the spacing of columns and the circumference of arches. Such forethought and rationalism were hallmarks of Renaissance architecture. The resulting churches may seem sterile at first glance, but the logic of their design has its own spiritual power.

Address
Piazza Santo Spirito,
Firenze 50125.

Map reference

Opening times
Daily 8.30–12 and 4–5.30.

Rebuilt c. 1383–1405

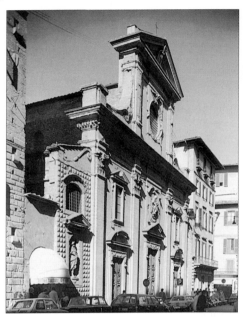

Address
Piazza Santa Trinità, Via
Tornabuoni, Firenze 50123.
© (1) 52 17 70

Map reference

Opening times
Daily 8.30–12.30 and
3.30–6.30.

The Vallombrosan Order settled here in 1092 and the small rounded arches of their Romanesque church can still be seen on the inside of the west wall. More remains of the earlier church can be seen by descending the staircase in the middle of the nave. In 1383 the monks raised funds to expand the church by petitioning the Signoria and by selling the decorative rights to eighteen chapels. The main body of the church, rebuilt in an expansive Gothic style, was largely finished by 1405. The facade was designed by Buontalenti (1531–1608) in the sixteenth century.

Amongst the notable patrons was Onofrio Strozzi, who paid for the hospital behind the church and was consequently given the right to decorate and be buried in the Sacristy. Palla Strozzi, the son of Onofrio, continued the tradition of family patronage by commissioning Gentile da Fabriano to paint an *Adoration of the Magi*, now hanging in the Uffizi, for this Sacristy. Also at the Uffizi is the *Maestà* by Cimabue which was the main altarpiece for this church. The Sassetti Chapel contains a fresco cycle by Ghirlandaio illustrating the life of St. Francis.

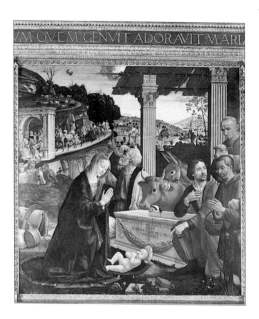

Like all the others in Santa Trinità, this chapel in the right transept is dedicated to one family, the Sassetti. Filippo Sassetti was the general manager for the Medici bank, and he and his wife Nera Corsi are depicted either side of the impressive main altarpiece, *The Adoration of the Shepherds*. Painted by Domenico Ghirlandaio (1449–94) this is a relatively rare example of the artist's use of egg tempera. The rest of the chapel is also by his workshop and represents a larger scheme illustrating the life of St. Francis, finished in 1485. *The Adoration of the Shepherds* was a relatively rare subject in the fifteenth century and its appearance here may be because the Vallombrosans followed the Order of St. Benedict and were thus devoted to poverty. The shepherds are being called by an angel in the top left of the picture as they sleep amongst their sheep; to the right shepherds of different ages present a lamb and some eggs to the infant Jesus. Joseph, in the centre, has the worried look of a man who wishes he had checked the invitation list, as he gazes across the hillside to see the Magi and their huge entourage approaching. Meanwhile Jesus, who lies on Mary's cloak, is unaware of the attention or the bullfinch in front of him which, by virtue of its red face reminiscent of blood, was the traditional prefiguration of Christ's death.

Of particular interest is the fresco above the altarpiece telling the story of how a child fell from a window of the Spini Palace and was revived by a mystical appearance of St. Francis. Among the details of this picture one can see the original facade of Santa Trinità, many portraits and the old bridge across the Arno, which was swept away by the great flood of 1555.

TEATRO ROMANO
1st century B.C.

Address
Teatro Romano, Fiesole.

Map reference

How to get there
No 7 bus from the Duomo.
At Fiesole walk down the
road leaving the piazza to
the left.

Opening times
Theatre open daily 9–7.
Museo Bandini open in
winter, 10–1 and 3–6; in
summer, 9.30–1 and 3–7.
Closed Tue.

Entrance fee
L 5,000. Joint ticket for the
Roman Theatre and the
Museo Bandini, L 6,000.

Fiesole predated Florence as a settlement and was one of the five Etruscan cities of Tuscany. The theatre dates from the first century BC, with later additions made by Septimius Severus to make it thirty-four metres across in order to seat 3,000 people. It is in fine condition, looking out over model Tuscan countryside, and far away from the noisy city. Plays are still performed here during the summer. Nearby are some Roman baths which most likely date from the first century AD. Also close by is a museum housing a small exhibition of Etruscan finds, which are memorable for their detailed workmanship. Just outside the gates, around to the right, is the Museo Bandini which contains two rooms of lesser-known, but nonetheless interesting, fourteenth- and fifteenth-century paintings. These include works by Bernardo Daddi, Taddeo Gaddi and the Della Robbia family.

ACKNOWLEDGEMENTS

The author and publishers would like to thank the following individuals, museums, galleries and photographic archives for their kind permission to reproduce the following illustrations:

Nicholas Ross: 6, 18, 20, 27, 28, 32, 58, 59, 61, 64, 66, 68, 69, 70, 71, 73, 85, 90, 93, 94, 96, 97, 99, 101, 103, 104b, 107, 110, 116, 118, 119, 121, 124.
Scala: 7.
Santa Maria del Carmine (photo Scala): 8, 16a&b.
Santa Maria del Carmine (photo Alinari): 111.
Galleria degli Uffizi (photo Scala): 9, 12a, 14a, 51b.
Galleria degli Uffizi (photo Bridgeman Art Library): 11.
Galleria degli Uffizi (photo Alinari): 37a&b, 38, 39, 40, 41a&b, 42, 43, 44, 45, 46, 47, 48, 49, 50, 51a, 52a&b, 53, 54, 55, 56, 57
A.F.Kersting: 10, 14b, 15b, 19, 29, 30, 36, 84, 86, 112, 122.
Santa Maria Novella (photo Scala): 12a.
Santa Maria Novella (photo Alinari): 113, 114, 115, 117.
Museo di Firenze Com'era (photo Scala): 13a, 15a.
Palazzo Medici-Riccardi (photo Scala): 13b.
Palazzo Medici-Riccardi (photo Alinari): 72.
Bargello (photo Alinari): 21, 22, 23, 24, 25a&b, 26a&b.
Duomo (photo Alinari): 31.
Accademia (photo Alinari): 33, 34a&b, 35.
Museo Horne (photo Alinari): 60.
Museo dell Opera del Duomo (photo Alinari): 62a&b, 63.
Museo Stibbert (photo Nicholas Ross): 65.
Ognissanti (photo Alinari): 67.
Palazzo Pitti (photo Alinari): 74, 75, 76, 77, 78, 79a&b, 80a&b.
Museo degli Argenti (photo Scala): 81.
Galleria d'Arte Moderna (photo Alinari): 82, 83.
Palazzo Vecchio (photo Alinari): 87, 88, 89.
Piazza della Signoria (photo Alinari): 91, 92.
Sant'Apollonia (photo Alinari): 95.
Santa Croce (photo Alinari): 98.
Santa Croce (photo Bridgeman Art Library): 100.
Santa Felicità (photo Scala): 102.
Laurentian Library (photo Alinari): 104a.
San Lorenzo (photo Alinari): 105, 106.
Museo di San Marco (photo Bridgeman Art Library): 108.

Museo di San Marco (photo Alinari): 109.
San Pancrazio, Museo Marino Marini (photo Nicholas Ross): 120 (© DACS 1995).
Santa Trinità (photo Alinari): 123.

The author would also like to thank Barnaby, Joan and Mark Ross, Mary Hollingsworth, Caroline Bugler, Julia Brown, Sarah Carr Gomm, Tom Parsons and Ben Taylor for their assistance.

Index of Artists, Architects and Sculptors
Figures in bold refer to main entries

INDEX

A note on the Itineraries

The following itineraries each cover half a day and the fourteen itineraries together build up to a full week's sightseeing, but visitors with less time to spend can obviously select according to their own preferences. Those with only a few hours at their disposal should concentrate on the starred items. Works of art are listed in the order that they are most likely to be seen within each museum or gallery. The numbers in circles beside each location are map references. Many state run museums are closed in the afternoons and all day Monday. State museums are also closed on public holidays: Christmas Day, 1 January, Easter Day, 25 April (Liberation Day), 1 May (Labour Day), the first Sunday in June and 15 August (Feast of the Assumption). The opening times of churches can vary significantly. Where they are known, they are listed with the relevant entry. As a general rule, however, churches tend to be open in the mornings from 7 to 12, and in the afternoons from 3.30 or 4 until 6.

Telephone numbers for museums are not always entered because, according to status, museums are administered from central offices run by the State or the Commune. A reliable source of information is the Tourist Information Office on the main concourse of the railway station: telephone (055) 282893 or 283500. There is also a Tourist Information Office at Via Cavour 1, Firenze 50129: telephone (055) 290833 or 290832. Except in a few cases where the museum is outside the centre of Florence and a bus is necessary to get there, there are no details of public transport because the visitor will generally travel everywhere on foot in the pedestrianized city centre. Bus tickets are purchased from tobacconists sporting a black, or sometimes blue, sign bearing a bold white T.

Entrance fees are marked with each entry. Citizens from European Community countries who are under eighteen or over sixty are allowed free entry to many museums. This is, however, at the discretion of the ticket clerk and passports must be carried for verification. All entrance fees and opening times are correct at the time of publication, but they may be liable to change without notice.

DAY 1 MORNING

✪ **GALLERIA DEGLI UFFIZI** ⑦ (p.36)
Closed Monday

Madonna and Child Enthroned
Cimabue (p.37)
Madonna and Child Enthroned
Duccio di Buoninsegna (p.37)
Madonna and Child Enthroned
Giotto di Bondone (p.38)
The Annunciation
Simone Martini (p.39)
The Adoration of the Magi
Gentile da Fabriano (p.40)
Federico da Montefeltro and Battista Sforza
Piero della Francesca (p.41)

The Rout of San Romano
Paolo Uccello (p.42)
Madonna with Child and Angels
Fra Filippo Lippi (p.43)
✪ **The Birth of Venus**
Sandro Botticelli (p.44)
Primavera
Sandro Botticelli (p.45)
The Adoration of the Magi
Sandro Botticelli (p.46)
The Entombment
Rogier van der Weyden (p.47)
Portinari Triptych
Hugo van der Goes (p.48)
The Baptism of Christ
Andrea del Verrocchio and Leonardo da Vinci (p.49)